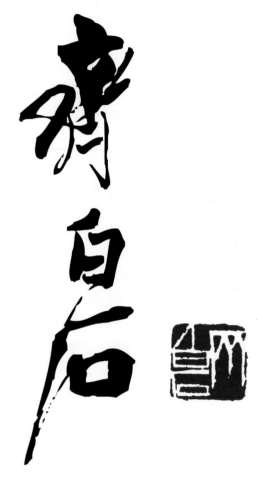

齊白石

藝 術 創 作 紀 念 展

Art Exhibition in Memory of Qi BaiShi

目　次

縣長序

　　現今是以文化創造價值的世代，當我們生活逐漸邁入已開發國家行列之際，為生命增添色彩，乃至豐富人文素養，培養國際視觀，已成為政府施政著重的目標，而文化質素的呈現也代表著一個城市是否偉大的象徵性指標。

　　我們可以發現，世界各大著名城市，無不以文化的軟實力立足於地球村。近年來，許多國家和城市紛紛以舉辦各種不同的主題性藝術文化活動，提高城市能見度，並與自身既有的傳統文化進行交流，為城市開啟多元的視野。而民眾也以舉辦這樣具有深層文化藝術的活動，而對自己所處的城市，多了幾分認同與驕傲。當我們提到東京、倫敦、巴黎、羅馬、紐約…，會對其藝術文化形象鮮明而心生崇敬。另外，許多後起的城鎮，如日本北海道、英國愛丁堡、澳洲雪梨、杜拜等，也因為一座建築或是舉辦藝術文化活動而成為舉世矚目的焦點，成為旅客最愛造訪的地方。因此，如何在眾多城市中成為耀眼的文化之都，並開創綠色經濟效益的信念，更加堅定了縣府團隊培養和創造自身文化的使命。

　　近年來，港區藝術中心不斷舉辦各項藝文活動，如：全國百號油畫展、臺灣美術新貌展、國際漆藝大展、鄭和下西洋600周年特展、成吉思汗紀念特展、布里亞特藝術家達西銅雕展…等，本縣的文化行政團隊戮力規劃各種特出的藝術文化活動，引起莫大迴響，在在提高民眾對於藝術創作的鑑賞、增進生活品味的廣度與深度。由於民眾的熱情參與，潛移默化下所培養出的文化內涵，對藝術的欣賞力及創意思考等，皆大幅提升大臺中地區的生活美學，加速文化培植與發展的契機。

　　此次舉辦「2009齊白石藝術創作紀念展」，即是希望藉由一位在人品、繪畫、詩句、書法、篆刻，無不出類拔萃，堪稱五絕的藝術家，讓民眾認識這位近代了不起的人物。齊白石的繪畫藝術造形簡練質樸，神態活潑，色彩鮮明強烈，筆酣墨飽，力健有鋒，具有深厚的傳統功力。人物、山水、花卉和各種翎毛魚蟲，無所不能，尤工蝦、蟹、蟬、魚，水墨淋漓，洋溢著生氣勃勃的氣息。藝術界的齊白石，如同文學界的蘇東坡，全身飽含深厚的中華文化，集各項才華於一身。若是能透過近距離的接觸與大師作品交會，定是臺中地區的鄉親乃至全國民眾的一大福音。

　　縣府行政團隊的腳步不會停歇，在面臨全球重大金融海嘯的當前，「開創新局、立足臺灣、放眼世界」是縣府同仁們努力的目標。我們深信，唯有從文化藝術著手，才能顯現與眾不同，賦予這片好山好水的土地強大生命力，進而感染每位來到這塊土地上的人們。透過文化藝術的扎根和交流，朝偉大城市邁進，展現身為臺中縣民的驕傲！

臺中縣縣長　　嚴坤生

Preface by the Connty Magistrate

It is now an age that focuses on using culture to create extra value that we need. When a country marches towards the goal as a developed country, its government naturally puts emphasis on adding colors to life, enriching humanistic elements and cultivating global view of points. The presentation of its cultural element also symbolizes the greatness of one city.

We can see a fact that almost all notable cities around the world occupy a corner with their cultural strength among the global village. In recent years, many countries and cities have held various artistic and cultural events with themes to increase their visibility in the world. These events also maintain a great interaction with local cultures to open a window to a diversified view of points. Though holding such cultural and artistic events, the residents also take pride in their cities and cultivate a sense of recognition. When mentioning Tokyo, London, Paris, Rome, New York and other major cities, we will admire for their active and lively image in artistic and cultural efforts. However, there are also place like Hokkaido in Japan, Edinburgh in Scotland, Sydney in Australia, Dubai and others that have become the favorites of tourists because of their recent efforts in holding cultural events or grand architectures. As a result, how to become one of the shinning cultural cities among those countries and the belief to create green economic effect has have thus consolidated that sense of mission in the county government to develop and create local cultures.

In recent years, the Seaport Art Center has held various artistic events, such as National Large-sized Oil Paintings Exhibition, Exhibition of New Perspective Art in Taiwan, International Exhibition of Lacquer Paintings, Special Exhibition on the 600th Year after Cheng-Ho's Great Voyage, Special Exhibition of Genghis Khan, Exhibition of Dashi Namdakov's Bronze Sculptor and other exhibitions. The cultural administrative team of the county government has endeavored to organize various special artistic and cultural events for the residents and responses were great. These events would elevate people's ability for artistic taste and enrich their people's lives. Owing to the enthusiastic participation from the general public, the aesthetic in the Large Taichung Area has been improved under such cultural influences. Local people's appreciation ability to arts and their creative thinking have thus fastened the pace for cultural development and cultivation.

The organization of " Art Exhibition In Memory of Qi Bai-shi's 2009 " aims to allow the general public to be more familiar with this notable artist who has par-excellent performances in five fields which are his personality, paintings, poems, calligraphy and sculptures. The paintings of Qi Bai-shi have simple patterns, lively atmosphere and vivid colors which present his experienced skills with pen skills, saturated dyeing, powerful and sharp outlines. He can draw people, mountain and water views, flowers and various insects. He is also specialized in painting shrimps, crabs, cicadas and fish. With his vivid expression in ink, his paintings are lively and energetic. Artist Qi Bai-shi enjoyed the equal fame as literary master Su Dong-po had. Qi was an artist who knew very well of his cultures and very talented. It will be a great blessing for the residents in Taichung area who are able to observe closely of this master's works.

The progress of county government's team will not stop. In the face of current financial tsunami, the members of the county government have a collective aim to "create new opportunities, think locally and act globally". We firmly believe that differences can only be sustained by achieving cultural and artistic successes, which will in turn empower a powerful vitality to the land and further influence the people on it. We wish that the people of Taichung county can take pride of their city through cultural root-taking and exchange that will eventually make it as one of the great cities in the world.

Huang, Chung-Sheng

Magistrate of Taiching Connty

局長序

在21世紀，隨著時代潮流及人類行為模式的改變，許多國家致力於文化藝術的保存和傳承，並藉由與創意產業的結合賦予新意，經由生活實用性的融入，不斷感動人心、陶冶性靈，文化藝術已逐漸深入人們的生活。因此，各年齡層、各族群民眾不但得以輕易汲取文化知識素養，甚至將其視為休閒娛樂活動，不僅參與、欣賞，更進入創作領域，修養藝術家氣息，讓人類的生活素養有「質的飛躍」。

齊白石大師，集詩、畫、印、刻四方才華於一身，可謂藝苑奇葩，他將自身的生命情懷寄託於畫作與篆刻中，畢生熱愛生命也熱愛創作，觀其作品總能品味出畫家健康爽朗、生意盎然的情調。其藝術創作的魅力，來自濃烈的個人特色，以及渾然天成的平民藝術風格，親切動人而無孤傲氣息，讓人易於從欣賞中體會藝術之情趣，毫無隔閡。繪花鳥，並非僅是物象於筆間的再現，而是透過畫家未泯的童心，重新再被賦予生命力，活躍紙上；而山水的寫意，往往在筆簡意遠、看似漫不經心的筆觸中出人意料。大師一生創作不倦，藝術可謂佔其生命之絕大部分，其藝術作品，隨時變易，但唯一不變者為其中所展現之樸實率真、穩重正直，充分體現其人格情操。

大師之藝術創作，著重於生活情趣的描繪，展現對生命與人文的熱情關懷，相較於現代人的忙碌生活，往往因急促步調而忽略生活的童真趣味。「2009齊白石藝術創作紀念展」的舉辦，正是為了讓一代大師齊白石的藝術創作，能在所謂新新世代的今天，持續發光發熱，在民眾心中引發藝術的共鳴。期待透過本次的展覽活動，經由大師的創作，喚起人人心中純真的童心，品味取材自生活和自然的創作風格，讓藝術成為生活與生命的載體，提升生活人文素養。同時，也希望能讓如此新意豐富的藝術創作，流傳久遠歷久彌新，繼續滋潤開拓著人們的文化心田。

臺中縣文化局局長　陳志聲

Preface by the Bureau Director

With the changing of trend and human behaviors in the 21 century, many countries have devoted in preserving and passing down their cultures and arts. They also combine cultures with creative industry to produce new ideas. Though the improvement in practicality, cultures and arts have become indispensible parts of people lives by giving emotional excitement and spiritual calmness to people. Therefore, people of various ages and ethnic groups are allowed to obtain cultural and artistic appreciation with each and further regard them as types of recreation. They can participate, appreciate arts or even become a creator of arts, making people's lives "a great leap in quality".

Master Qi, Bai-Shi has great talents in poetry, painting and sculpture. He was a genuine master by nature in the arts field. He laid his life and emotions on paintings and sculptures. He enjoyed his life wholeheartedly and endeavored selflessly to artistic creation. When appreciating his works, one can sense the open-minded and lively atmosphere on his works. The charisma in his works is a result of strong personality and the natural wide-accepted style. His works are amiable and touching to people, as well as people can easily appreciate the spirits in works because of their lack of pride and division. Those painted flowers and birds are not merely the creation by drawing pens, they are the recreation processed by the artist's child-like point of view, thus they look lively on the paper. For the presentation of mountain and water views, they are often simply drawn, but contain unexpected vividness in them. Master Qi has created works with non-stop efforts. Arts played a major part of his life. Though his painting subjects varied from time to time, the only things that can be observed in all his works are his simplicity, sincerity, calmness and honesty, which are the elements of his personality and characteristics.

The creation of Master Qi was focused on the description of life events. He showed a great interest in life and humanistic activities. Compared to that, the hectic pace of modern people has made us lose our child-like humor because of it. The organization of the exhibition is trying to promote the artistic creation of the master to be able to continue its influences in the current days of "new new generation". We hope this exhibition can arouse people's inner recognition. We hope the exhibition can revitalize the child-like humor in everyone through Master Qi's creation. As result, people can appreciate the style derived from life and the nature, making art a platform for life and existence to elevate humanistic appreciation. At the same time, we also hope these artistic creations can be passed down for a long time and continue to nourish people's arid hearts.

Chen, Jhih-Sheng

Director of the Cultural Affairs Bureau

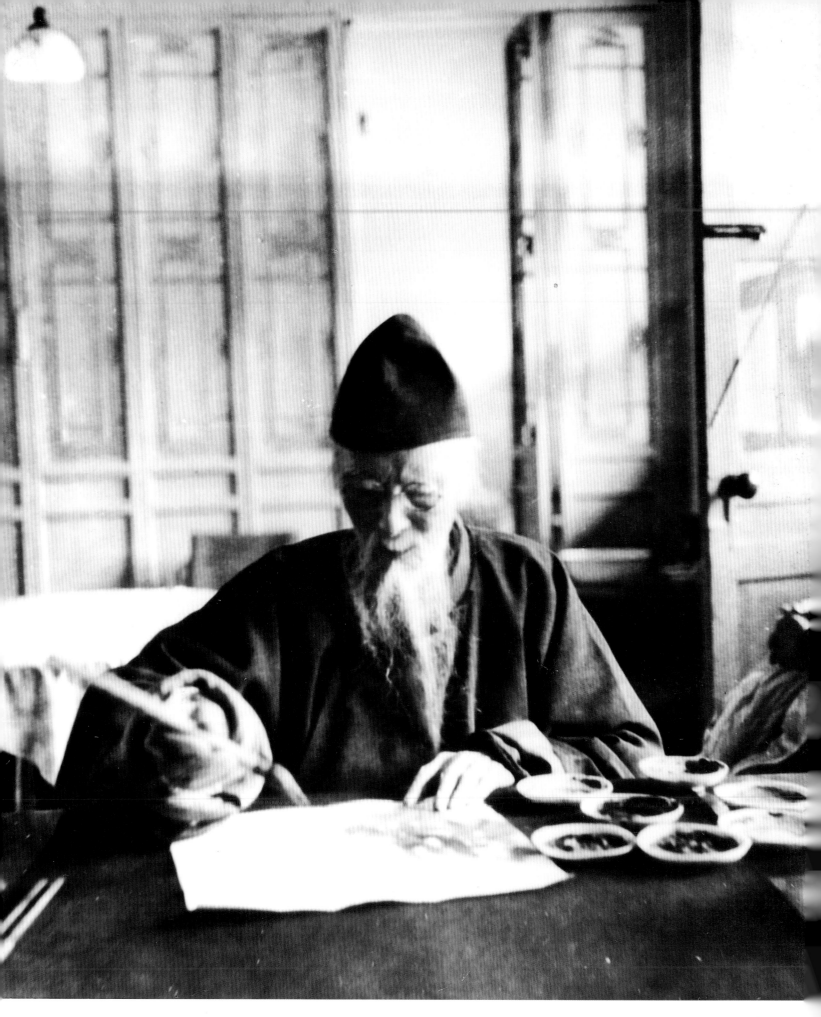

白石畫如白話詩--- 簡介齊白石的藝術

<div align="right">明道大學藝術中心主任　羅　青</div>

前言：齊白石與五四人物

　　1919年在北京掀起的「五四新文藝運動」，迄今已經90周年，歷來論五四人物的文章，汗牛充棟，但對最能彰顯「新文藝運動」創作精神的兩位國際級藝術大師：齊白石（1864-1957）與梅蘭芳（1894 -1962）師徒二人，卻鮮少有人以重要「五四人物」視之，加以申論。

　　21歲就成名的梅蘭芳，在五四運動之前5年，就以傳統京劇爲基礎，推出時裝新戲，一新觀衆耳目，是「借古開今」的典範，後來更成爲名震世界的國際藝術大師。已習畫十載的梅蘭芳，在32歲那年（1925）拜63歲的齊白石爲師習草蟲。此時，齊白石的畫，剛經過67年的"衰年變法"，建立了鮮明的自我風格，不單名震北京，而且聲動東瀛。齊氏於1917年初抵北京，於1918年初識陳師曾，開始改革戶畫法，並於1919年五四運動時，正式定居北京，爲中國墨彩畫，開闢新的天地。

　　齊白石的畫，廣受五四新文化運動健將的喜愛，胡適、羅家倫、老舍、凌淑華…都十分推崇他的畫。他也與胡適、老舍等有密切的交往，爲他們創作，並互通聲氣。例如他應老舍命題所畫的《蛙聲十里出山泉》，已成爲20世紀中國墨彩繪畫的代表作之一。1946年白石老人83歲，把自己的傳記資料，交給胡適，請他寫傳記編年表。胡適於1949年編成《齊白石年譜》由上海商務印書館出版發行。我們從胡適1954年跋齊白石的兩則畫語中，可見他是多麼的喜歡齊氏的作品：其一爲"民國38年1月，我向汪亞塵借得這一幅玉蘭花，印作白石年譜的附錄。看他畫花畫瓶，何等力量，何等簡單，何等工緻！王方宇先生收得原畫，使我妒羨。" 其二爲"這幅不倒翁是白石老人最有風趣的小品，我曾借印入白石年譜。王方宇先生與我有同好，出力求得原本，他要我題短跋，做個紀念。"[1]

　　齊白石的作品，之所以受到五四人物的喜愛，是因爲他的最好的繪畫語言與成功的白話文學，有許多相通之處，二者都是以平民生活的喜怒哀樂爲題材，都是文白融合而又深入淺出，看似明白易懂，但卻又結構嚴謹，最後臻至寓意深遠，耐人尋味的境界。最後，以90高齡仍創作不懈的老畫師，憑著他動人的藝術作品，也與梅蘭芳一樣，揚名世界藝壇，受到世人的寶愛。

齊白石的藝術

　　1956年，齊白石（1864-1957）以94歲（自稱96歲），爲自己的畫集，《齊白石作品選集》寫自序云：

> 國內外競言齊白石畫，予不知其究何所取也；印與詩則知者稍稀。予不知知之者之爲眞知否？
> 不知者之有可知否？將以問天下後世。

　　口氣之中，自謙裡含有自傲，反映了他自15歲鄉隅困學，到60歲京華成名，一生由"技"進"道"，自創藝術風格的艱辛心情。[2] 他的藝術，在中國墨彩繪畫史上，可稱之爲"齊家樣"而當之無愧。

1　王方宇、許芥昱合著英文本《Ch'I Pai-shih's Paintings 看齊白石畫》（台北：藝術圖書公司出版，1979年）頁 29-87。

2　"由技進道"典出《莊子·養生主》，其中"庖丁解牛"一則云："臣之所好者道也，進乎技矣。"《莊子·天道》中之"輪扁斫輪"；《徐無鬼》中之"郢匠運斤"《達生》中之"佝僂承蜩"…等等，皆言此理。

不過，名滿世界年高德劭的他，沒有倚老賣老自賣自誇，也沒有被中外的讚譽所惑，他在爲自己畫集所寫的最後序文裡，依舊堅持回歸藝術最基本的問題：自己的創作有何 "可取" 之處？內容有何 "可知" 之處？而一般人所爲的 "知" 是否爲 "真知"？還是僅僅人云亦云的 "耳食" 而已？[3] 其追根究底、追求 "真可取"、"真可知" 的精神，是白石老人一生，留給後人最寶貴的遺產。

　　齊白石生於1864年1月1日（農曆癸亥11月22日）於湖南湘潭縣杏子塢星斗塘農民之家，爲長子，派名純芝，字渭清、蘭亭。4歲，隨祖父齊萬秉識字。8歲，從外祖父周雨若讀書，習《千家詩》：《白石自狀略》云："性喜畫。以習字之紙裁半張畫漁翁起。外王父（周雨若）常責之，猶不能已。" 是年秋因病輟學。11歲，讀《論語》。12歲，娶陳春君爲童養媳。

　　齊白石的藝術語言學習，從民間木作雕花圖案開始。15歲，爲生計，拜本家叔祖齊仙佑爲師學粗木工，因體力弱小，遭辭退；後改從齊長齡學粗木工，是年秋，決意學細木工。16歲，拜著名雕花木工周之美爲師，改學細木工。19歲，周氏賞其手藝學，准其出師，仍隨侍師傅，在白石鋪一帶做木工，人稱爲 "芝師傅"、"芝木匠"。

　　在民間藝術語言的基礎上，他開始追溯學習墨彩繪畫語言的歷史脈絡。遲至20歲，他才得見套色《芥子園畫譜》，如獲至寶，借回勾摹、染色，歷時半年告成，裝訂成16冊。26歲，拜蕭傳鑫爲師，學畫肖像；後入肖像專家文少可指點，兼得中西肖像畫法門徑。

　　以繪畫語言表達自己感情思想的基礎既立，他開始習詩文以充實自己的文學修養，嘗試以文字表達自己的情思。27歲，拜胡沁園、陳少蕃爲師，學工筆花鳥草蟲及讀《孟子》、《唐詩三百首》，《唐宋古文八大家》，又隨譚溥（號荔生）習山水。更名 "璜"，號 "瀕生"，別號 "白石山人"。 其他字號還有寄園、齊伯子、畫隱、紅豆生、寄幻仙奴、木居士、木人、老木、寄萍、老萍、萍翁、寄萍堂主人、杏子塢老民、湘上農民、借山吟館主者、借山翁、三百石印富翁、齊大、老齊郎、老白等。是年，書法入何紹基體。

　　他從28歲開始讀白香山《長慶集》，初識 "元白詩派" 之寫法與精神，棄去木工，在家鄉杏子塢、韶塘一帶爲人畫像及賣畫謀生；並隨蕭薌陔學裱褙。32歲 ，與王仲言、羅眞吾、羅醒吾、陳茯根、譚子銓、胡立三藉五龍山大傑寺爲址，成立 "龍山詩社"，因年長，被推爲社長。

　　藝文之道的方向確定後，他進一步，觸類旁通，在34歲，開始鑽研刻印，第一顆印爲 "金石癖"，尤工丁龍泓、黃小松兩家；37歲正式拜湖南詩文泰斗鄉賢王闓運（壬甫1833-1916）爲師，以期在詩文創作上取法乎上，更上層樓。[4] 是年，他自拓《寄園印存》4本，展現其研習刻印的源流與「歷史感」。其印章之佈白，與書法之創作，從此開始相互影響，互通有無。

　　38歲，自星斗塘遷出，佃居蓮花峰下梅公祠，營建 "借山吟館"。40歲，應友人夏午詒之邀赴西安教畫，結識當時的大名士大詩人樊樊山（1846-1931），詩畫刻印受到賞識，親手爲之書 "齊白石刻印潤例單" 一

3 白石老人曾做《耳食圖》冊頁，諷刺人云亦云者。
4 王闓運（1833-1916）晚清經學家、文學家。字壬秋、壬父，號湘綺。湖南湘潭人，出生於長沙，幼資質駑鈍但好學，《清史稿》說他 "昕所習者，不成誦不食；夕所誦者，不得解不寢。""經、史、百家，靡不誦習。箋、注、抄、校，日有定課。" 因此成爲一代宗師。

張。[5] 樊增祥以 "詩如茶飯" 的生活化理念寫詩，力主清新，與白石詩風近似。從這年起，他的畫法，由工筆漸趨大寫意。

41歲，隨夏午詒赴北京，結識李筠庵、曾熙、楊度等，開始臨寫魏碑，書風爲之一變，爲後來以金石與篆刻之筆入畫作準備；是年夏，取道天津，經上海回湘。此後他又 "四出四歸"，四處賣畫，體悟詩道博大精深，非具宿根劬學不辦，未易言驕，改 "借山吟館" 爲 "借山館"，買屋、置地，將房屋翻蓋一新，取名 "寄萍堂"：又在堂內建書室，置遠遊所得八塊硯石於內，名爲 "八硯樓"，刻印譜《白石草衣金石刻畫》，王湘綺爲撰序文（刊於《白石刻畫》卷首），還爲其《借山圖》題詞，此時他的山水已開創自己的風格。43歲，刻印入趙之謙體。

48歲以後，他歸鄉山居，創作不輟，收穫頗豐。此時他所吟之詩，多近白話，即情即景，不尙用典，以樸實清新爲高。他整理遠遊畫稿，繪《借山圖》冊，以簡遠奇警爲宗，一新山水畫法，開創自己獨特的山水構圖風格：畫花鳥時，多取法八大、石濤、李鱓之法：畫草蟲則多工致寫生，間或以寫意出之，始號 "萍翁"，此爲其日後在畫中，展現「工」、「寫」強烈對照的淵源。

55歲，爲避家鄉兵匪之亂，隻身赴京，逢 "張勛復辟"，轉赴天津避難。亂後回京，住法源寺，結交陳師曾、淩直之、汪靄士、姚茫父、陳半丁、王夢白等人，從師曾處，得到啓發，大幅提升繪畫思想及美學境界。10月初返湘，家中已被洗劫一空，遂刻 "丁巳劫灰之餘" 印章以紀其事。

1919年正月，再至北京，以賣畫、治印爲生，時年56歲。其時，求畫者不多，自是年開始 "衰年變法"，創 "紅花墨葉" 一派。自云："余作畫數十年，未稱己意。從此決定大變，不欲人知。即餓死京華，公等勿憐，乃余或可自問快心時也。"[6] 是年，他決定聘四川胡寶珠爲副室，準備定居北京。9月，聞家鄉又有戰事，返湘，得緣創作《南嶽不倒翁》，找到他繪畫的第一個 "獨門意象"。58歲，攜三子良琨、長孫秉靈來京，是年結識梅蘭芳、林琴南、賀履之、朱悟園等名人名士，從此交遊漸漸廣闊，名聲日高，而他的 "獨門意象"，發展迅速，爲中國墨彩畫語言，增加了許多 "新詞" 與 "新意"。

60歲時，返湘接家人北京同住，運勢爲之一轉：是年春，陳師曾攜中國畫家作品東渡日本，參加 "中日聯合繪畫展覽會"，齊白石之畫，引起藝界轟動，售價豐厚；不久，又有作品，入選巴黎藝術展覽會，名氣益盛。61歲，陳師曾在南京去世，白石哀痛逾恆，數次題詩祭悼好友，始作《三百石印齋記事》。63歲，梅蘭芳、徐悲鴻爲齊白石印行畫集，推崇他 "由匠而變，妙造自然"，此年梅蘭芳正式拜齊爲師，習畫草蟲。有衆多名人相挺後，他的畫名，此後一直長紅不衰，享譽中外藝壇，逾40年。

同時代畫家，在藝術影響力上，能與齊白石(1864-1957)相頡頏者，只有與他同庚的黃賓虹(1864-1955)，二人是中國近代畫壇的雙璧，同年出生、同享高壽、同得大名、出入古今、同臻晚成、同垂青史。張彥遠

5 樊增祥（1846－1931），字嘉父，號雲門，又號樊山、天琴，湖北恩施人。光緒三年（1877），中進士，工詩善書，尤精楷法，墨黑如漆，古厚稚拙，自成一家。散館後，出補陝西渭南縣知縣，累官陝西、江寧布政使。其人 "頗負一時清望"，文章政事儼然大家，詩歌判牘皆有盛名。《新編樊山批判精華》之 "凡例" 亦謂 "樊樊山先生文章政事爲當代泰斗。" 張之洞云："洞庭南北有兩詩人，王壬甫五言，樊樊山近體，皆名世之作"。李慈銘亟稱其材，曾謂 "其七律足追蹤唐之東野、義山，而古體勝之" 樊增祥師事張、李二人，而詩境並不與相同，"論詩以清新博麗爲主，工於隸事，巧於裁對 ... 數月又易本"。《光宣詩壇點將錄》謂其 "生平以詩爲茶飯，無日不作，無地不作"。

6 陳凡編《齊白石詩畫文篆刻集》(台北：河洛圖書出版社景印，1975年)頁32。

《歷代名畫記》"論顧陸張吳用筆"云："若知畫有疏、密二體，方可議乎畫。" 齊白石畫，爲近代疏體代表，然疏中有密；黃賓虹畫，爲近代密體代表，然密中有疏；二人皆爲一代豪傑，爲後世開出無限法門。[7]

齊白石的繪畫語言，是文言文的"淺白化"，有如文白夾雜式的"宋明語錄體"，充滿了日常生活的親和力；又如李白詩："床前明月光，疑似地上霜。" 3歲小兒皆可解，雅俗都能共同欣賞。不過，齊白石的繪畫語言，再怎麼淺白，仍然是屬於文言文體系的，無一定修養者，難以眞正入門。尤其是能夠從平正中見奇特，最是難能。

齊氏筆墨「文化歷史感」的淵源，與黃賓虹大不相同，他的繪畫語言偏向歷代「逸品」與「疏體」傳統，最早可以追溯到米芾、梁楷的簡筆畫風，然後順倪瓚、沈周、徐渭、朱耷、石濤、高其佩、李鱓、黃愼…等名家的「疏體風格」而下，直至張賜寧、曾衍東、胡公壽、蒲作英、吳昌碩，一系相承，脈絡清晰。

藝術修養淺者，可以愛其題材生活化、構圖清新化，賞其筆法活潑有情，色墨淋漓痛快。藝術愛好深者，可以在他粗枝大葉的筆墨之中，看到歷代「疏體」繪畫的傳承，並欣賞他與古今「逸品」大師的對話。而兩者都可以在他大筆濃墨的花鳥畫中，意外發現有細筆勾勒的工筆草蟲，品嚐到「疏密」藝術對比中的巨大激情，體會出對照反差間的無上樂趣。

至於深通書史畫史者，則知道重視齊白石的金石筆法，欽佩其中鋒的古拙厚實，偏鋒的遒勁潑辣；激賞其率性用色的大膽狂放，濃墨淡墨的對照耀眼；讚嘆其取材構圖的奇特不俗，水暈墨張的自然渾成；景仰其生活創造的融爲一體，精微入妙的造意設境。

齊白石之線條用筆，深得八大山人、金冬心、趙之謙、任伯年、吳昌碩之影響，充滿了書法的結構，篆筆、隸筆，長短粗細之間，快狠穩準，有如用刀，無不充滿了金石之氣，十分耐看。

齊白石之用墨，輕重濃淡，筆筆清楚，決不堆疊。他善於用水，讓宣紙忠實反映水墨筆痕，刻畫出動物的肌理、植物的紋路，把元代張守中所發展出來的半工半寫的墨彩畫風，與後來寫意名家的種種新意，融匯貫通，自成一家。

齊白石之用色，是寓痛快於沉著的，大紅之後，一定配上沉靜的花青與墨色，去其火氣；如通幅都是濃墨淡墨，則必補重色數筆，點醒全畫；調配靈活，俗而能雅，決無艷俗之態。

齊白石之山水構圖，喜走險棋，多從邊角向中心圍來，以實圍虛，再翻虛爲實，或上下盡量拉開距離，用題字聯繫兩端的空間，以少勝多，氣勢開闊，有不盡之意。他在給門人張次溪的書簡中，再三強調："承命畫《雙肇樓圖》，以佈置少，能見廣大，覺勝人萬壑千坵也。貴樓題詞甚多，不必題於圖上，使拙圖地廣天空，若嫌空白太多，加書題句，其圖有妨礙也。" 可見他在山水構圖的立意上，是以「疏體」爲主，以「平正見奇」爲歸依。

總之，齊白石的繪畫美學是"妙在似與不似之間"，也就是儒家中庸之道，"並不一味的刻意求似"。他

7 張彥遠《歷代名畫記》，見于安瀾編《畫史叢書》第一冊，(上海：上海人民美術出版社，1963年)，頁27。

主張：“能在不求似中得似，方得顯出神韻。”他不但能夠抓住物像的神韻，同時也能通過物像，傳達自己的神韻。如此創作，最能抓住觀者的心意，引起大家的共鳴。

不過，他雖然反對“宗派”與“臨摹”他也從不死板寫生。他只是從自然中取材構稿，然後重組變化創造，畫做最後的結果，以藝術精神體驗為歸依，不以自然實證經驗為歸依。他在面對真實經驗之餘，並不反對創造性的繼承傳統，因為藝術語言，在自然之外，自成體系，源遠流長，不能繼承就無法發揚。

齊白石畫在內容上的特色是忠於生活、忠於童年經驗、忠於農村生活，畫中充滿了天真赤子之心，幽默詼諧之趣，選擇題材平民通俗，處理手法戲劇對比，構圖位置新奇大膽，筆法墨韻博古通今，這就是他的繪畫之所以能夠老少咸宜，雅俗共賞的原因。他是中國墨彩畫史上，第一個以大量畫作，回憶童年與鄉村生活的畫家，其“童鄉作品”的地位，足可與胡適的《四十自述》，與周作人《知堂回想錄》相比。

白石的畫，以「中得心源」的個人經驗為契機，藝術史圖像經驗為輔助，強調筆墨色彩三元素，要在「外師造化」的原則下，經過藝術的提煉重組後創新。因此他的山水、人物、花鳥，在構圖及立意上，總是以「疏體風格」為主，「清新奇警」為上，出入「造化」與「畫史」之間，獨抒己意，勇往直前，為反映工業民主社會的繪畫，指出了新的方向。

因此，我們可以說，他的畫與他的詩一樣，都是白話化的文言詩，有如五四初期，尚未脫離文言文影響的白話詩，清新可人。他的詩，近黃遵憲、樊樊山，有如從竹枝詞、歌謠體中，轉化而來。他的畫，則如胡適之、劉大白的新詩，清新如在目前，但又充滿了古典的薰陶，真正達到了雅俗共賞的地步。

在中國藝術史上，能不斷從個人生活經驗出發，參考各種雅俗的藝術養分，以「日記式」的態度，「平民式」的精神，逐年創作，記錄自己的感情與思想，齊白石當算得上是第一人。

參考書目

陳傳席主編《白石留韻》（北京：人民美術出版社，2008年）

齊白石繪《白石自珍》（天津：天津人民美術出版社，2005年）

郎紹君《齊白石畫集》（台北：羲之堂文化出版公司，2002年）

齊白石（張次溪筆錄）《白石老人自述---插圖珍藏本》（台北：城邦文化事業，2001年）

劉焯、楊廣泰編《齊白石雙譜》（瀋陽：集古齋有限公司出版，1999年）

戚宜君《齊白石外傳》（台北：世界文物出版社，1993年）

香港集古齋編《齊白石暨門人畫展》（香港：香港集古齋出版，1991年）

北京文物商店編《齊白石書畫集》（北京：人民美術出版社，1986年）

藝術家雜誌社編《藝術家106期--齊白石專輯》（台北：藝術家雜誌出版社，1984年3月）

干方宇、許芥昱合著英文本《Ch'I Pai-shih's Paintings看齊白石畫》（台北：藝術圖書公司出版，1979年）

陳凡編《齊白石詩畫文篆刻集》（台北：河洛圖書出版社景印，1975年）

余毅然編《齊白石作品集》（台北：中華書畫出版社景印，1969年）

Buchheim Verlag Feldafing ed., Der Maler in Herbstlichen Hain, Chinesische Landschaften von Chi Pai Shih （Berlin, Bchheim Verlang Feldafing, 1964）

Vernacular Poetry and Vernacular Painting — The Art of Qi Bai-shi

Lo Ching-Che

~~Forewords: Qi Bai-Shi and his associates of the May Fourth Movement~~

Ninety years have past since the May-Fourth New Literature and Art Movement first initiated in Beijing in1919. Among the numerous essays and researches devoted to the study of the Movement, Qi Bai-Shi (1864-1957) and Mei Lan-Fan（1894 -1962）, two internationally well known artists that share a mentor-protégé relationship, seemed being overlooked and excluded completely from this context. Their achievements in painting and drama respectively are best demonstrated in their energetic creativities with widely critical acclaims, however they are seldom considered as the major leading figures of the May-Fourth Movement.

As a matter of fact, five years before the Movement, Mei Lan-Fan, at the age of 21, already a national celebrity, had reinvented traditional Beijing Opera in the format of modern Western theater, which revolutionized Chinese theatrical performance with new sensibilities and has become a paradigm of "eclecticism between the past and present". From then on, within ten years of time from, Mei successfully made himself a world-wide renowned Chinese Opera Star, a maestro of Kuan Musicals . At the age of thirty-two (1925), Mei who had studied ink-color painting for over ten years began to learn Flower-and-Bird painting from the 63-year-old ink-color painting master Qi Bai-Shi, who had just evolved his art into an unique and vibrant style after undergoing six years of "reformations". His new approach not only shocked the viewers' eyes of Beijing, but also astonished those in Japan.

A native of Huna province, Qi first visited Beijing in 1917 and made his acquaintance with the famous artist-scholar Chen Shi-Zeng who later influenced him greatly regarding his acquisition of a new aesthetics accompanied by a resolutely determined mind to change his painting course from low key subtleness toward bold combinations different brush works and sharp contrasts of applying ink and color in the field of Flower and Bird painting. In 1919, the year of the outbreak of the May-Fourth Movement, he decided to move to Beijing to live permanently there. With the arrival of Qi in the art scene of the imperial capital, Chinese ink-color painting is about to witness a new era.

Qi Bai-Shi's paintings are highly appreciated by the activists of the May-Fourth New Culture Movement, its leading figures such as Hu Shih, Luo Jia-Lun, Lao-She, and Ling Shu-Hua. He maintains close friendship with Hu Shih, Luo Jia-lun, and others, paints for them, and keeps frequent discussions. For example, the *Frog Calls from the Spring Ten Miles Away* he has painted upon request and with topic given by Lao-She is now one of the most representative Chinese color ink paintings in the 20th Century. In 1946 and at the age of 83, Bai-Shi provides his own biography material to Hu Shih and commissions Hu to author a biographical annalistic table. In 1949 Hu Shih completes A Chronicles of Qi Bai-Shi and authorizes Shanghai Commercial Press to publish. Hu Shih's affection for Qi's paintings is best illustrated with two of Hu's prefaces for Qi Bai-Shi in 1954: "January 1949, I borrowed a painting of white champak from Wang Ya-Chen as my reference for Bai-Shi's chronicles. Just look at the flower and the vase he has painted! They are so powerful, so simple, so sophisticate! I envy Mr. Wang Fang-Yu, the lucky owner of this painting!" "This painting of tumbler is the most amusing work of Bai-Shi, and I borrowed it for the printing for Bai-Shi's chronicles. Mr. Wang Fang-Yu shares a common habit with me that we all try our best to acquire the originals. He has asked me to write a

[1] Wang Fang-Yu and Xu Jie-Yu, *Qi Bai-Shi's Paintings*, Taipei: Art Books Co., Ltd., 1979, pp 29-87

short preface." [1]

The reason why Qi Bai-Shi's artworks are so adored by the May Fourth Movement personages is that his finest painting language shares many similarities with the vernacular literature; both focus on the emotions of the populace, both are mixtures of classical and vernacular style that explains the profound in simple terms but maintains stringent structure; both imply moral message and inspire ideas. This old painting artists keeps on painting even at the age of 90. His touching works of art, like the artworks by Mei Lan-Fan, become internationally known are treasured by the world

Qi Bai-Shi's Art

In 1956 at the age of ninety-four , Qi Bai-Shi (1864—1957) penned the preface of his own painting collection, *Selective Works of Qi Bai-Shi:*

> *People of the world talk about Qi Bai-Shi's paintings, I don't know the reasons why they love them so much. I may know something about seals and poems. I don't know whether those who claim that they know really know, whether those who don't know may know. I shall leave the questions to the next generations.*

In his tone he seems to be humble but proud of himself. This reflects his struggle with the lacking of formal education in a poor countryside since the age of 15, and his success in Beijing as late as the age of 60. All his life is a difficult journey of elevation from technique-oriented to the state of art with his own unique style.[2] In the history of Chinese color ink painting, his artworks may be categorized as Qi's Style with full credits.

Despite of senior age and high esteem, he never sings about his own praises or allows himself to be blinded by the publicity. Instead, he still insists on the fundamental of art that in the last preface he writes for his own painting collection, he says: "What is advisable about my own artworks? What have my artworks inspired? Is the realization as common people know of a true realization, or is it merely hearsay?" [3] Qi Bai-Shi's relentless pursuit of true realization is the most valuable legacy that he leaves behind.

Qi Bai-Shi is born on January 1, 1864 (or the 22nd day of the 11th month on lunar calendar) at Xingdoutang, Xingziwu, Xiangtan County, Hunan Province as the first boy in a famer's family. His given name is Chun-Zhi, and style names are Wei-Qing and Lan-Ting. At the age of 4 he starts to learn words from his grandfather, Qi Wan-Bing. At 8, he learns to read a classic literature of *Qianjiashi* from his maternal grandfather, Zhou Yu-Ruo. In his own autobiography, *Qi Bai-Shi, A Short Autobyography*, he says: "I just love painting; I begin to paint fisher man on a piece of paper that I cut in halves from a writing sheet. My maternal grandfather (Zhou Yu-Ruo) often blames me, but that does not stop me." In the same year he discontinues his study due to illness. At 11 he begins to study *The Confucius Analects*, and at 12 he marries Chen Chun-Jun, who is a child wife.

[2] "From technique-oriented to the state of art" is quoted from the *Yang Sheng Zhu , Book of Zhuang Zih*, in which a fable story of "A Cook slaughters a Cow" says: "I embrace only the universal way of everything; it is how I learn my technique." The same idea is also found in the fable stories of "Lun Bian the Wheel Maker" in *Tiandao, Book of Zhuang Zih*, 'The Craftsman's Skillful Use of Ax" in "Xu Wu Gui", and 'The Humpback Old Man Catching a Cicada" in 'Da Sheng" .

[3] Qi Bai-shi makes the satirical painting of Er Shi Tu to mock on the people who believe in hearsay.

Qi Bai-Shi's learning of art begins with wood carvings. At 15 he becomes an apprentice of his carpenter uncle, Qi Xian-Yu, but is fired soon due to his weak strength. In the fall of the same year he determines to learn joiner. At 16 he follows a celebrity wood carving master, Zhou Zhi-Mei, as a joiner apprentice. At 19 he is given the mastership by Zhou for his brilliant performance, but he chooses to stay and serve Zhou and works as a joiner in Baishipu area. He is referred as Master Zhi or Joiner Zhi.

With the foundation of folk art, he begins to learn and trace back the history of color ink painting. He has never seen the *Mustard Seed Garden Painting Menue* until he is 20. Once he has a glimpse on it, he borrows it home in extreme excitement to delineate and recreate the colors; it takes him 6 months to complete, and the result is 16 volumes of collection. At 16 he learns figure portrait from Xiao Chuan-Xin and Wen Shao-Ke. Now he knows the essences of both Chinese and western portrait techniques.

As Qi Bai-Shi has established the foundation to express his emotion and philosophy with painting, he begins to study poem to enrich his literature quality and prepares himself to express his affection with language. At 27 he follows Hu Qin-Yuan and Chen Shao-Fan to learn fine-brush paintings of natural objects and classic literature, such as *Mengzi, 300 Tang Poems : An Anthology*, and *The Collection of the Eight Famous essayists of Tang and Sung Dynasties*. Later on he also studied landscape and figure paintings from Tang Fu (style name Li-Sheng). He then changes his own given name as Huang and assumes a style name, Bin-Sheng and an alias, Bai-Shi Shanren (or Bai-shi the Mountain Hermit). His other style names and alias include Jiyuan, Qibozi, Huayin, Hondousheng, Jihuanxiannu, Mujushi, Muren, Laomu, Jiping, Laoping, Pingweng, Jipingtangzhuren, Xingziwulaomin, Xiangshangnongmin, Jieshangyinguanzhuzhe, Jieshangweng, Sanbaishiyinfuweng, Qida, Laoqilang, and Laobai. At the same year he adopts the calligraphic style of Ho Shao-Ji.

He begins to study *Changqingji* written by Bai Xiang-Shan and comes to realize for the first time about the technique and spirit of Yuan-Bai poetry school. He then quits the joiner job and changes his occupation to portray artist in Zinziwu and Shaotang areas, selling paintings to earn his living. Meanwhile, he also follows Xiao Xiang-Gai to learn picturing mounting. At 32 he and Wang Zhing-Yan, Luo Zhen-Wu, Luo Xing-Wu, Chen Fu-Gen, Tan Zi-Quan, and Hu Li-San establish the Longshan Poetry Club at a borrowed space of Dajie Temple in Wulong Mountain. He is chosen as the chairperson of the club due to his senior age.

Once the direction of his pursuit of art has been confirmed, he learns by analogy. At 34 he begins to learn seal carving. His first work is Jinshipi. He is particularly good at the carving styles created by Dong Long Hong and Huang Xiao Song. To further perfect his poem writings, at 37 he learns more poetry from Wang Kai-Yun (or Wang Fu, 1833-1916), who is a poetry master in Hunan province.[4] In the same year he makes 4 volumes of rubbings from inscription of Jiyuanyincun (as a demonstration of the origin of his study of seal carving and his sense of history. The seal carving layout, from this point onward, begins to influence his calligraphy, and vice versa.

[4] Wang Kai-yun (1833 - 1916) is scripture scholar and litterateur in the late Qing Dynasty. His style name is Renqiu and Renfu, and alias, Xiangqi. His domicile is Xiangtan City, Hunan Province, and his birthplace is Changsha City. He is born without outstanding talent, but he studies very hard. According to *Qingshigao*, he is a student so determined that he will not eat if he can't recite what he has learned, and he will not sleep at night if he can't understand what he has recited in the evening. He studies all the classic literatures; scriptures, histories, philosophies, everything. He routinely makes bookmarks, comments, transcriptions, and proof-reading, everyday, That is why he is recognized as a grand master scholar,

[5] Zhang Yan-Yuan, *Lidaiminghuaji, Huashicongshu* Vol. 1, Shanghai People's Art Publisher, 1963, pp 27.

At the age of 38 he moves out of Xingdoutang and rents a room in Meigongci Temple at the mountain foot of Lianhuafeng; he calls his place Jieshanyinguan . At 40 he travels to Xian on invitation of his friend, Xia Wu-Yi to teach painting. There he makes acquaintance of Fan Fan-Shan（1846－1931）, who is a celebrity poet, and who likes Qi's poems and paintings so much that he writes Qi a calligraphy as gift, Qi's Seal Carving List.[5] Fan Zeng-Xiang's philosophy about poems is "a poem is like a routine meal". The style of his poems is similar to Qi's. Since this year, Qi's painting style gradually moves from fine brush to freehand style.

At 41 he follows Xia Wu-yi and travels to Beijing, where he meets other artists like Li Yu-An, Zeng Xi, and Yang Du. Qi begins to adopt the font of tablet inscription of Wei Dynasty; it is a dramatic change of his calligraphy style, and a preparation for incorporating his study of ancient inscriptions and seal carving into his paintings. The summer of that year he returns to Hunan by way of Tianjin and Shanghai, where he leaves from and returns to for four more times to sell his paintings. During such period he realizes that poetry is so profound that he must devote to it completely for poetry to flourish. He changes the name of his room from Songs of the Barrowed Mountains to House with the Barrowed Mountains, buys land and house and remodels it, and names the house Bayanlou. He authors the *Bai-Shi Caiyi Jinshikehua*, and Wang Xiang-Qi writes the preface for him (included in the top page of *Bai-Shi Kehua*), and inscribes a poem on Qi's painting, Jieshantu. Now Qi has his own landscape painting style. At 43 he adopts the carving style of Zhai Zhi-Qian.

After 48 he retreated to countryside to continue his art creation, and the result is quite fruitful. His poems in this period are mostly vernacular style; no difficult patterns, only simplicity, He also consolidates the drafts he has made in his previous trips to make the *Jieshantu*. These paintings adopt simple wide angle glimpses in structure, which is a brand new painting style that Qi may call it his own. When painting birds and flowers, he mostly adopts the styles of Bada Shanren, Shi Tao, and Li Shan, and plants and insects, sophisticate life portrait mixed with improvised freehand style. At such time he assumes a new style name of Pingwen. It is the beginning of the significant contrast between sophistication and freehand in his later paintings.

At 55 Qi has to flee from home that falls to the hands of bandits, and he chooses to go to Beijing along. But again Beijing is in a chaotic state due to munity of a warlord, Zhang Xun. Qi turns to Tianjin for escape. After the conflict is over, Qi returns to Beijing and lives in Fayuansi Temple, where he makes friends of other artists: Chen Shi-Zeng, Ling Zih-Zhi, Wang Ai-Shi, Yao Mang-Fu, Chen Ban-Ding, and Wang Meng-Bai. He learns more about painting and becomes so inspired that his painting escalates to a higher level of philosophy and aesthetics. He returns to Hunan in early October but to find his home completely robbed. To record this event, he makes a seal called the "Survival of the year of loot of 1917".

In January 1919, At the age of 56, Qi visits Beijing again and makes his living by selling paintings and making seals. At that time, there is only few buyers. He then begins his own transformation by creating a style of Red Flower and Ink Leafs. He says: "I have been painting for decades and I am not satisfied with my artworks. Therefore I have determined to undergo a major change and I do not want others to know. I would rather starve to death here in Beijing. Don't pity on me, my friends; this is what I really want to try." In the same year he adopts a concubine, Hu Bao-Zhi, a woman from Sichuan, and makes Beijing his new home. In September he is informed that another war breaks out in his hometown, and he rushes back. There he creates the painting of Nanyue Budaoweng, which is the first unique image that he has found for his own painting. At 58 he takes his third son, Linag-Kun and the oldest grandson, Bing-Ling to

Beijing. In the following year he makes friends of celebrity artists like Mei Lan-Fan, Lin Qin-Nan, He Lu-Zhi, and Zhu Wu-Yuan. Since then his social circle expands and his reputation increases. Meanwhile, his unique image develops rapidly, giving many new words and new meanings to the language of Chinese color ink painting.

At 60 he returned to Hunan to bring the rest of his family to Beijing. Good fortunes finally find him in the spring of that year. Chen Shi-Zeng takes some paintings of Chinese artists to Japan for the China-Japan Joint Exhibition of Painting, where Qi Bai-Shi's paintings receive high regard and popularity, and, most importantly, great revenue. No sooner his artwork is selected for an art exhibition in Paris. His fame is climbing up. At 61, Chen Shi-Zeng passes away in Nanjing, and Qi mourns for him and makes poems, among which is the Note of the Studio of 300 Seal Stones, At 63, Mei Lan-Fan and Xu Bei-Hong jointly published the Collected paintings of Qi praising him that "transformed from a painter, his paintings are all natural" . In the same year Mei Lan-Fan officially becomes Qi's protégé and learns paintings of plants and insects. With the support from many celebrities, his reputation in painting remains high for a very long time, more than 40 years.

Among other painting artists at that time, only Huang Bin-Hong (1864-1955), at the same age, is comparably influential as Qi. The two artists are the double elites in Chinese modern painting. They both are born in the same year, able to enjoy a long life, highly regarded, successful at later time in life, and recognized in history. In the entry of "On the Executions of brushstroke of Master Gu, Lu, Zhan and Wu" of Lidaiminghuaji, Zhang Yan-Yuan comments : "One must be able to tell the difference between the compact style and that of the loose in painting before one can make any comment on art." Qi's painting is a representation of modern loose style, but there is still compact style in his loose style, On the other contrary, Huang's painting is a representation of modern compact style, and there is loose style in his compact style. Both are all high achievers, and they open up to door to unlimited possibilities for the artists of the later generations.

If Qi's painting is a language, then it is the simplified classic literature, like the *Songmingyuluti*, a classic literature mixed with vernacular and ancient classic styles and filled with easy, friendly subjects. Qi's artworks are easy to understand, like Li Bai's popular poem of "The bright moonlight spreads on the bedroom floor like the frost on the ground." Even a child may comprehend without problem. Both scholars and peasants may enjoy. However, Qi's painting language is after all a part of the ancient classic style; it will take some effort in study to fully appreciate its essence, and this is exactly the beauty of Qi's paintings.

Compared with Huang Hong-bin, Qi has a different origin of his sense of history in his artworks. His paintings are more of exquisite and loose style traditions, which can be traced back all the way to the simplicity style of Mi Fei and Liang Kai. The transition then clearly follows the loose style, which is mostly represented by Ni Zan, Shen Zhou, Xu Wei, Zhu Da, Shi Tao, Gao Qi-Pei, Li Shan, and Huang Shen, to the style of Zhan Ci-Ning, Ceng Yan-Dong, Hu Gong-Shou, Pu Zuo-Ying, and Wu Chan-Shuo.

Those who with less training of art may found Qi's painting lovely for their daily life subjects, clear structure, vibrant emotion, and pleasant palette. Art enthusiasts, on the other hand, may find the legacy of traditional loose style painting in Qi's rough strokes and appreciate the dialog between Qi and the exquisite masters of both ancient and modern times. All may inadvertently find the fine outlines in the plants and insects and feel the great passion in the contrast of compact-loose styles, within which the unlimited amusement can be found.

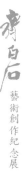

Those who know really well about ancient literatures and paintings will know the importance of Qi's carving-like strokes and admire the classic and plain weight in the middle of the strokes and the powerful and spicy ending strokes. The choice of colors is bald and wild, and the contrast of density of ink is brilliant. The framing structure is unique, and the dilution of the ink is natural. He lives out creation in his life, and that is why his paintings are full with minute image settings.

The outline and stroke in his painting are essentially influenced by Bada Shanren, Jin Dong-Xin, Zhai Zih-Qian, Ren Bo-Nian, and Wu Chan-Shuo that his paintings are laid out like calligraphy of seal character font and official script font. Between the bold and thin strokes, there are precision, determination, and stability, just like a perfectly carved seal.

Qi's application of ink tones, varying from very light to extreme dark, is always accompanied by powerful strokes precise and accurate that never overlaps into multiple blurring layers. He is also very good at controlling the scattering of the water-ink effect on rice paper which faithfully records and reflects the minute movement of the brushes that depict the textures as well as the lines of the featured animals and plants. He fuses the innovations in ink-color painting tradition with a special emphasis on the technique of mixing the brushworks of realism and free interpretation developed by Zhan Shou-Zhong of the Yuan Dynasty and coines them into his own unique style.

The palette in Qi's painting hides passion in calm. Whenever there is bright red, there must be accompanying calm blue and dark gray to ease out the tension. If the majority of a painting is a mixture of light and dark ink, there must be several heavy strokes to complement the theme. Vigilant and dynamic; they are pleasant to all but never settle for vulgarity.

Qi likes to take risky steps in the framing structure of his landscape paintings. They converge from the corners, surrounding the loose subject with solid objects, and then reverse the loose to compact. Or, there is a significant vertical distance, which is filled with calligraphy to connect the top and the bottom, giving it a grand gesture with infinite abstract. In the letters to his protégé, Zhang Ci-Xi he reiterated: "Regarding the painting of Shuangzhailoutu, remember less is more. Only a few great mountains are better than countless mountains. Too many calligraphic inscriptions are not needed, so the sky and the land can be seen. If there are too many blank spots, a touch with simple writings is better than filling them with more paintings." Obviously, loose style is the primarily adopted in the framing structure for landscape painting and the purpose is "bring the extraordinary out from the ordinary".

In conclusion, the aesthetics in Qi's paintings exists in the non-existence; a correspondence of the Doctrine of Mean of the Confucian school. Never seek for fidelity. He says: "the essence can only be revealed by presenting the fidelity among the infidelity." Not only he can capture the essence of an object, but also convey his own interpretation through such object. This is how his creation captures the minds of spectator and makes resonance.

However, he never makes blunt sketching despite that he opposes to faction and imitation by copying. He finds the topics from the nature and re-arranges the elements for art creation. He values spiritual experience instead of empirical experience. Having say so, he does not oppose to creative legacy because art itself is a legacy; it can't exist without legacy.

Qi's paintings are loyal to life experience about childhood and farm life; innocent, humorous, and common. His dramatized contrast, bald and amusing framing structure, and integration of classic style and avant garde are the reasons for his popularity. He is the first painting artist in the history of Chinese color inks who commemorates childhood and farm life with an incredibly large amount of artworks. His works focused on his childhood and countryside experience can be considered as equally important as the famous autobiographical masterpieces of the May-Fourth Movement: *Being 40, An Account of My Early Life* by Hu Shi and *Rememberance of the Past of Zhitang* by Zhou Zuo-Ren.

Qi's paintings are based on personal experience and aided with imagery experience of art history with emphasis on the three elements of stroke, ink, and color and the principle of learning from the nature, and created by re-assembly after artistic refinement. Therefore, his paintings always center on loose style and focus on refreshing innovation in the framing structure and theme, whether it is landscape, portrait, flowers and birds. Between the nature and painting history, Qi is one of his own kind, and points out a new direction for the paintings that reflect the industrial and democratic society.

Therefore, it may be concluded that both his paintings and poems are vernacular classics, just like the refreshing and lovely vernacular poems not yet disengaged from ancient classic style during the early May Fourth Movement period. His poems, like the ones of Huang Zun-Xian and Fan Fan-Shan, seem to transformed from peasant songs. His paintings, like the new poems of Hu Shi and Liou Da-Bai, are refreshingly vivid as if the subjects are right in front spectators' eyes, yet are fully seasoned with classical essence. They are loved by all and accessible to everyone.

In Chinese art history, Qi is probably the first and the only painter who constantly finds inspirations from his daily experiences ordinary and extraordinary, embracing both literati and mundane art subjects to create series of paintings and poems chronologically like keeping a diary, recording his emotions and ideas.

References

Chen Chuan-Xi; *Bai-Shi Liuyun*; Beijing: People's Art Publisher, 2008.

Qi Bai-Shi; *Bai-Shi Zinzhen*; Tianjin: Tianjin People's Art Publisher, 2005.

Lang Shao-Jun; *Qi Bai-Shi's Painting Collection*; Taipei: Xizihtang Gallery, 2002.

Qi Bai-Shi (Zhang Ci-Zi Bilu); *Qi Bai-Shi's Recount - Collection of Illustration* ; Taipei: Cite Group, 2002.

Liu Zhuo & Yang Guang-Tai *Qi Bai-Shi Shuagpu*, Shenyang: Jiguzhai Co., Ltd., 1999.

Qi Yi-Jun; *Unofficial History of Qi Bai-Shi*; Taipei: Mercury Publishing House; 1993.

Hong Kong Tsikuchai; Exhibition of Paintings of Qi Bai-Shi and His Protégé ; Hong Kong: Hong Kong Tsikuchai; 1991.

Beijing Cultural Relics Store; *Qi Bai-Shi Calligraphy and Painting Collation*; Beijing: People's Art Publisher; 1986.

Artist Magazine; Vol. 106, Qi Bai-Shi special edition; Taipei: Artist Magazine; March, 1984.

Wang Fang-Yu & Xu Jie-Yu; *Qi Bai-Shi's Paintings*; Taipei: Art Books Publishing House; 1979.

Chen Fan; Qi Bai-shi Artworks Collection Taipei: Heluo Publishing House; 1975.

Yu Yi-Ran; Qi Bai-Shi Collection; Taipei: China Gallery; 1969.

Buchheim Verlag Feldafing ed., Der Maler in Herbstlichen Hain, Chinesische Landschaften von Chi Pai Shih (Berlin, Bchheim Verlang Feldafing, 1964)

繪畫作品

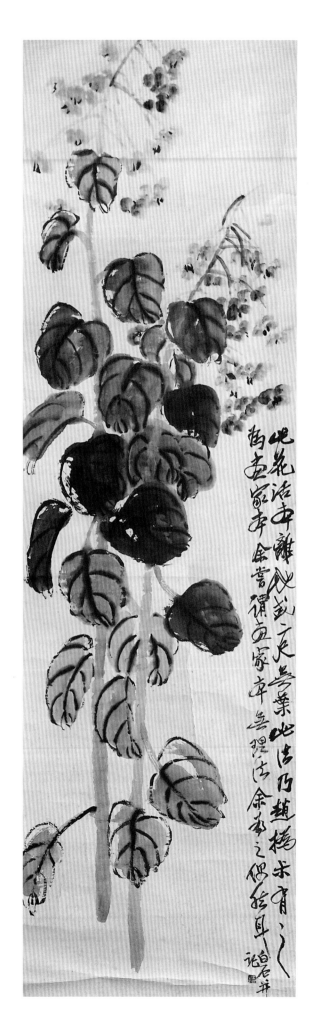

海棠圖　　　水墨、宣紙
162×47.5cm

款題：此花活本　離地或二尺　無葉　此法乃趙
　　　撝叔有之　為畫家本　余嘗謂畫家本無理
　　　法　余為之　偶然耳　白石並記
印章：木居士（朱文）

　　兩株海棠頂天立地，上下左右，各盡勢態。
其花其葉，淺淺深深，正側掩映，一任自然，極
富變化。似乎有點風，使高高的兩株海棠有些左
右晃動，這是生命的旋律，是田園奏鳴曲。畫右
題記告訴觀畫者：大自然中的海棠花，高二尺
許，沒有葉。這幅畫的畫法，清代趙之謙有過，
是畫家筆下的海棠。而畫家筆下的花卉，往往與
自然中的不相同，他這樣畫，不過偶然罷了。從
此題跋我們可以看到，齊白石是尊重大自然、主
張對花寫生的。這幅海棠與自然相悖，還特意說
明，唯恐以訛傳訛，足見其創作態度之嚴肅認
真。

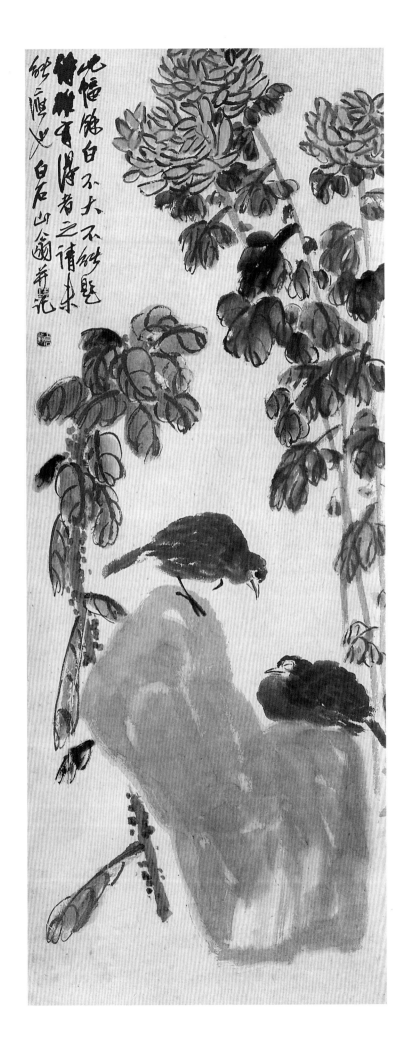

菊石雙鳥圖　　水墨、宣紙
119×45.5cm

款題：此幅餘白不大　不能題詩　雖有得者之請
　　　未能應也　白石山翁並記
印章：木居士（白文）

　　如此大幅，不易佈局，難得滿，難得空靈，
又難得變化。從畫幅來看，齊白石卻顯得輕鬆自
如。此畫構圖是以中軸線為基準左右對稱展開佈
局的，而在對稱中卻極盡平衡變化之能事。中間
一石突兀而起，高低兩峰、兩鳥均各具姿態，左
峰立鳥，如高屋建瓴，鳥向前俯視，其重心向
下，有動感。右峰較低，鳥取蹲式，閉目凝神，
顯得平靜安詳。石後的左峰高而雁來紅略矮；右
峰低而菊花稍高。雁來紅的紅色與菊枝葉的花青
色互為襯托，頂部菊花的黃色起著中和的作用。
一鳥在畫的中心，頗為奪目，但與其四周均衡。
整幅筆墨、色彩、物象各安其生，協調而恰到好
處。畫面已夠豐富了，左上角題數語既點明了本
幅不能加題詩句的理由，題字與石、鳥的墨色亦
有呼應的效果。

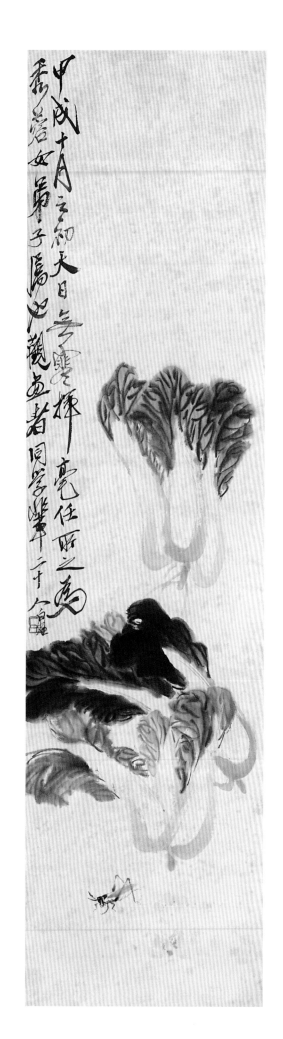

白菜蟋蟀　　　　　水墨、宣紙
　　　　　　　　　　132×34cm　1934年

款題：甲戌十月之初　天日無寒　揮毫任所之
　　　為秀蓉女弟子屬也　觀畫者同學輩二十
　　　人　白石
印章：白石（朱文）

　　吳昌碩畫的白菜，像書齋裏的清供，染上
了一些書香氣。而齊白石畫的白菜，卻宛如從畦
地裏剛剛出土。畫面上水墨畫就三棵大小、舒
卷、深淺不同的白菜，乾淨、壯實，帶著泥土的
芳香，並配上一隻振翅而鳴的蟋蟀。他用篆書筆
法中鋒一轉鋒，準確地勾出白菜的輪廓，再用蹲
筆刷出菜葉，然後用小筆破墨勾筋，使菜葉墨色
豐富，層次分明。三棵白菜的方位聚散穿插得恰
如其分。那隻蟋蟀，與菜葉的方向相反，好似剛
從白菜堆中蹦出來，靜中寓動，更使畫面活躍起
來。有人問齊白石，怎樣才能將白菜畫得這樣
好，齊白石回答：「通身無蔬筍氣，但苦於欲似
余，何能到。」一語道出其中奧秘。只有熟悉了
對象，才能把對象畫好。此圖是老人在北平國立
藝專或京華美專任教時課堂上所作，他以輕鬆愉
快的心情，把筆墨技巧發揮到極致，為同學們做
了這次演示。

三餘（魚）圖　　水墨、宣紙
133.5×34cm

款題：予為子潘弟畫三餘圖　　閬仙弟亦求之
　　　白石山翁璜
印章：白石翁（白文）

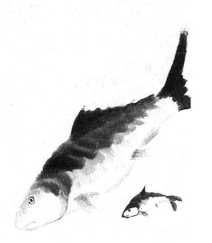

　　自古以來，中國文人和畫家的結合，漸漸形成文人畫，或者畫文化。文化豐富了畫的內涵，畫趣滿足了文人的口味。畫端題詩、題跋、用印，使畫境和詩文境界合二為一、水乳交融。畫上有魚就意味著有餘，或連年有餘；畫三條魚，意味著"三餘"。"三餘"原是三國時魏國人董遇教誨學生珍惜時間的典故，他謂"冬者歲之餘，夜者日之餘，陰雨者時之餘"。陳壽把這件事記述在所著《三國志・魏志・王肅傳》中，後成為了人們的格言。齊白石給學生一再畫此圖，除了示範、留念之外，還意在勸學。齊白石畫魚，學過八大山人，但八大畫魚和鳥，均側目而視，白眼看人，有一種憤世嫉俗之感。而齊白石畫的魚貼近生活，給人以親切感。由於注重墨色的變化和空白的處理，畫面顯得空靈和充滿生氣。至於齊白石自己創意的"三餘"說："詩者睡之餘，畫者工之餘，壽者劫之餘"，當另有一番意義了。

福祿 鴛鴦　　水墨、宣紙
　　　　　　　　68.5×34cm

款題：福祿鴛鴦（篆）寄萍老人白石
印章：齊大（朱文）

　　幾片荷葉以不同的姿態簇擁著一枝亭亭玉立的荷花，荷葉墨色富於濃淡變化，與荷花的紅瓣、黃蓮蓬、黑蕊形成強烈的色彩對比，使人感到清新、嬌豔。荷葉下的一對鴛鴦剛穿過荷梗自右向左游出，前一隻似乎在回頭看，與後面的伴侶打招呼。齊白石畫荷花，首先學八大山人和李復堂。他五十歲時總結前人經驗並有所想法，曾題畫云："懊道人畫荷花過於草率，八大山人亦畫此過於太真，余能得其中否？自尚未信，世有知者當不以余言為自誇耳，食者自當竊笑也。"此後，他在臨摹古人技巧之後，對荷花反覆觀察、寫生，用繁簡兩種對立的不同手法進行創作，均獲成功，並在畫秋天殘荷的畫法上創開了新的局面。齊白石畫鴛鴦，有濃豔和清麗兩種用色方法。這一對稚拙的鴛鴦，用花青畫肩羽，用墨畫腹和尾，嘴殼的紅也很淡，只有前胸和帆羽用藤黃畫，較為奪目，屬於清麗的著色方法，給人以淡雅的感覺。畫上端題的"福祿鴛鴦"四個篆字，既有《漢祀三公山碑》和《吳天發神讖碑》的影響而又自具性格，有一種童稚氣彌漫於字裏行間。荷花象徵著和平、和氣、和為貴，福祿意味著幸福、榮耀、富裕、祥和，而鴛鴦則代表了神聖純潔的愛情與和睦的家庭。這是我國民眾的普遍理想與追求。

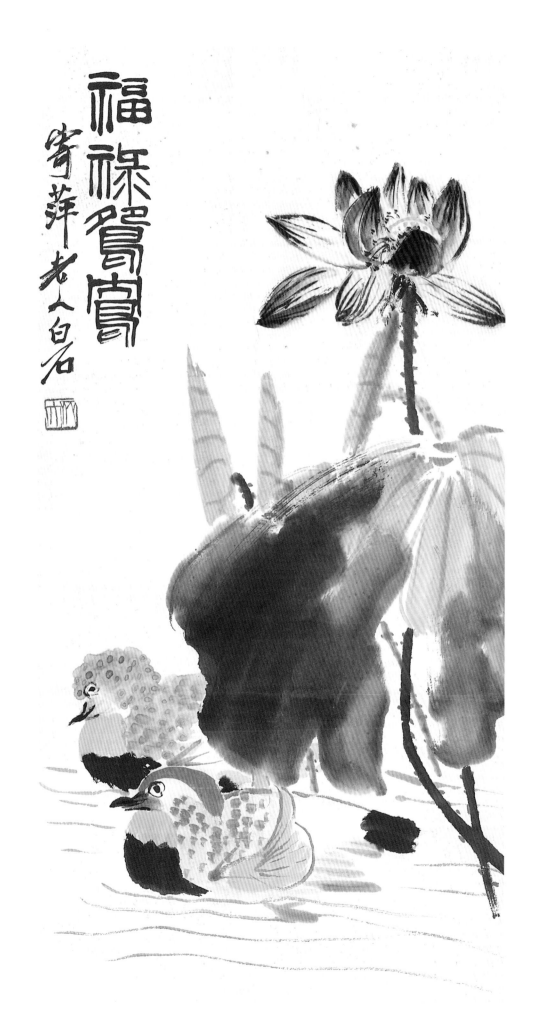

雁來紅蜻蜓　　水墨、宣紙
　　　　　　　　　68×34cm　1920年

款題：希商夫人清屬　庚申冬十一月　齊寶珠贈
　　　求老夫白石畫
印章：老白（朱文）　白石畫蟲（朱文）

　　雁來紅又名老少年，是傳統繪畫花卉題材。清人畫此本，設色較淡雅，線條柔暢，給人以清雅之感。吳昌碩畫雁來紅用石鼓籀篆筆法，設色濃重偏紫，給人以雍容大度與龍鍾老邁之感。至齊白石畫雁來紅，則立枝挺拔，勾葉筋線條清剛爽利，設色濃豔絢麗而富於深淺層次變化，給人以朝氣蓬勃之感。他曾以《畫老來紅》詩寓意云："年過五十字萍翁，老轉童顏計已窮。今日辭歸扶對鏡，朱顏不讓老來紅。"詩中表達了他對青春年少的回味和羨慕；又以年老於畫藝的進取而自信，預示著一個紅霞滿天的晚景將會來臨。畫中配上一隻工筆黑蜻蜓，工與寫、黑與紅相襯映，整幅畫便活脫脫地生氣盎然了。從題款中可以看出，原來是為寶珠夫人贈給希商夫人而畫，為此，"老齊郎"可不得不認真作業了。

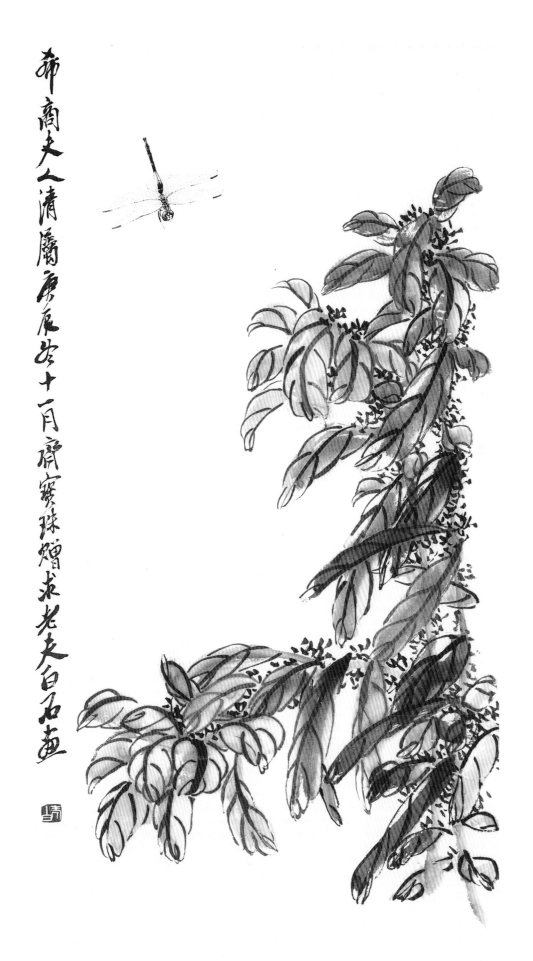

希商夫人清屬庚辰岁十一月齊寶珠贈求老夫白石畫

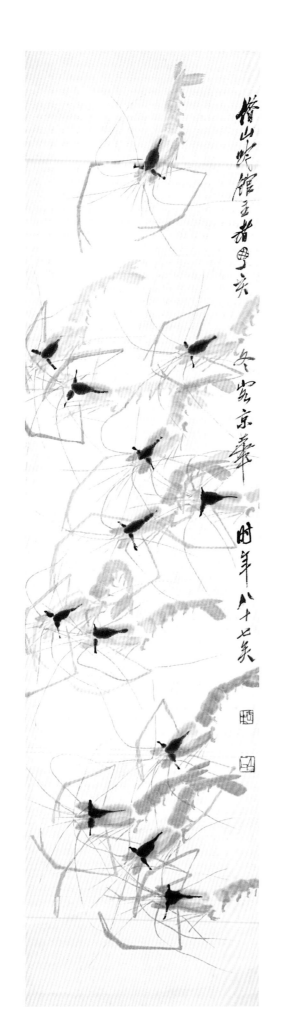

群蝦圖 　　水墨、宣紙
　　　　　　135×33cm　1947年

款題：借山吟館主者　丁亥冬　客京華　時年八
　　　十七矣
印章：老木（朱文）　白石（朱文）

　　"吾畫蝦幾十年始得其神。"這是齊白石關
於畫蝦的自白，可見畫蝦得其神的難處。他五十
八歲以前畫蝦，多參照八大山人、李復堂、鄭板
橋等的畫法，造型一般，墨色少變化。六十歲時
畫法開始有變化。六十四歲時技法嫻熟且富變
化。經過反覆觀察寫生、提煉取捨，改進畫法，
數年後才初步形成具有自己特徵的畫蝦法，蝦的
形象個性亦明朗起來。他總結這一階段的探索
道："余之畫蝦，已經數變，初只略似，一變逼
真，再變色分深淺，此三變也。"七十歲以後，
無論從造型到筆墨到神韻，均進入自由王國，才
真正爐火純青、形神兼備，成為古今畫壇的一
絕。此圖是一件蝦的精品。群蝦分成隻數不同、
若即若離的幾組，有的蝦舞弄著鬚、鉗，有的在
遊弋，有的如喁喁耳語，似在敘說著水中世界的
冷暖，抑或議論著水族之間的逸聞趣事…，畫面
沒有水紋，也未畫水草，卻仿佛呈現出一片晶瑩
透澈、夢幻般的水底世界。在波光水影中，群蝦
通體透明，如美玉、如瑪瑙、如水晶…。

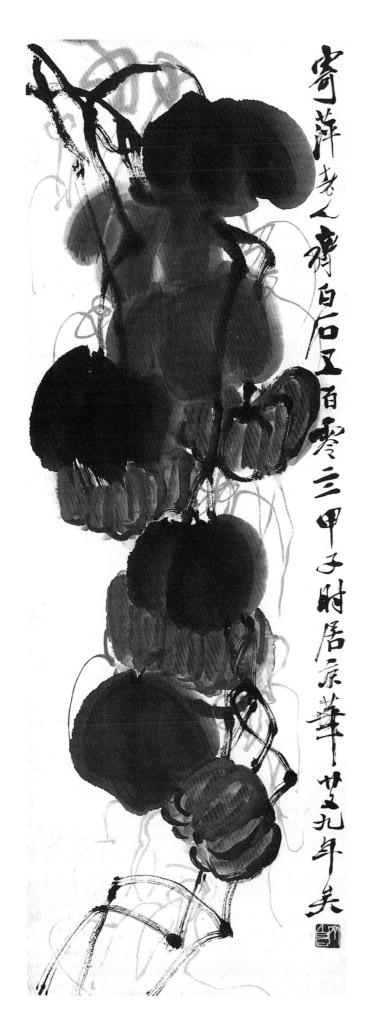

倭瓜 　　水墨、宣紙
　　　　　101×34cm　1945年

款題：寄萍老人齊白石　五百零四甲子　時居京
　　　華廿又九年矣
印章：齊白石（白文）

　　早年的農村生活，使齊白石對蔬菜瓜果、花
卉草蟲等描繪對象成竹在胸，他不但精於畫小花
卉，而且善於畫大瓜果。畫小花卉難見精微，畫
大瓜果則須有氣勢。此圖一改畫倭瓜多用橫向章
法的常規，從上至下一氣到底，瓜藤畫得虯蟠蒼
老，瓜葉畫得滋潤茂盛，把葉子毛茸茸的質感表
現出來。而畫瓜實，用篆書筆法以濃墨勾出輪
廓，再以赭石平塗著色，顯得壯實沉著。瓜、
葉、藤的方位，參差錯落，筆墨亦富於變化。用
淡墨隨意勾畫的小藤絲，增添了生氣，多了層次
變化，使畫面多了對比度。如果不是這些交錯的
變化手法，此畫容易落入俗套；如果沒有齊白石
的匠心、見地和駕馭筆墨的本領，畫面一定會顯
得平庸和單調。簡單的題材和物象要畫豐富，確
實只有大手筆才能為之。

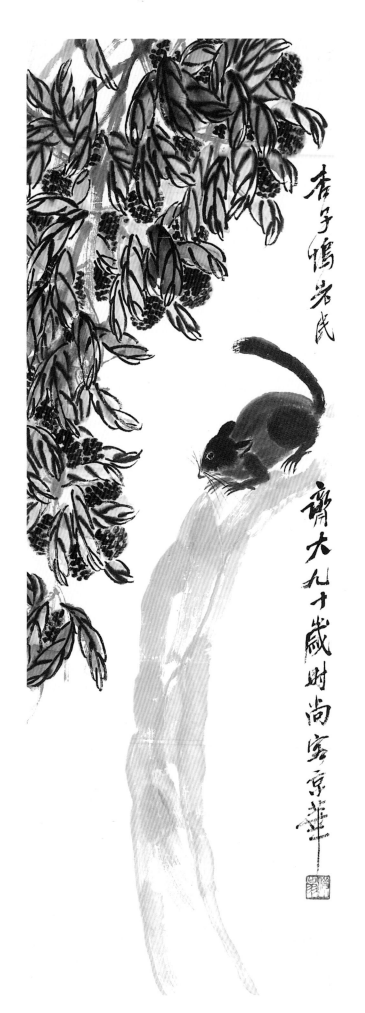

荔枝松鼠圖　　　　水墨、宣紙
　　　　　　　　　　105×34.5cm／1945年
 1950

款題：杏子塢老民齊大九十歲時尚客京華
印章：借山翁（朱文）

　　荔枝，佳果也，美食也。荔枝自古以來與文
人、畫家結緣既早又深。晉嵇含《南方草木狀》
對荔枝就有描述。唐代韓愈撰有《荔子丹碑》
（蘇東坡書），杜牧則留下“一騎紅塵妃子笑，無
人知是荔枝來”之句，以刺譎唐明皇的朝政。宋
代蔡襄著有《荔枝譜》。蘇東坡被貶到廣東惠州
和海南儋縣時，更是被荔枝的色香味所動而忘記
了貶謫的苦惱，寫下“日啖荔枝三百顆，不辭長
作嶺南人”的詩句。齊白石親眼看到荔枝樹、親
口品嘗鮮荔枝果，是他“五出五歸”的第四次遠
遊，即光緒三十三年（一九〇七）四十五歲時的
欽州之行。有詩為證：“客裏欽州舊夢癡，南門
河上雨絲絲。此生再過應無分，纖手教儂剝荔
枝。”齊白石畫荔枝有自家法。此幀《荔枝松鼠
圖》尺寸不過一張三尺條幅，卻使人如對巨構。
樹身突兀挺立，繁枝茂葉，果實累累自上垂下，
如串串瓔珞，青翠的枝葉間，果實鮮紅濃豔，潤
澤欲滴。枝、葉、果似在微風中擺動。以淡墨畫
的主幹，上實下虛，顯出樹的高大。一隻濃墨與
淡墨相襯映的松鼠，在樹幹向上彎曲處小心地走
過來，想吃荔果卻又必須抓緊樹幹，如不小心，
就有可能跌下來。齊白石準確地刻畫出了這種對
立統一的心理狀態。

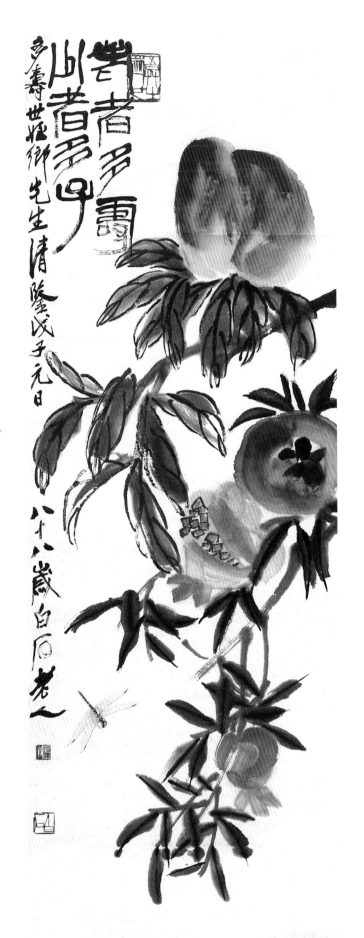

壽桃石榴蜻蜓圖

水墨、宣紙
104×34.5cm　1948年

款題：老者多壽　少者多子（篆）　多壽世侄鄉
　　　　先生清鑒　戊子元日　八十八歲白石老人
印章：借山翁（白文）　白石（朱文）　吾草木
　　　　眾人也（朱文）　人長壽（朱文）

　　應一位同鄉晚輩之請而作於一九四八年的這
幅《壽桃石榴蜻蜓》立軸，無疑是白石老人的經
意之作。一枝桃、一枝石榴從右邊伸入畫面，樹
枝如寫篆，勁健、老辣而有生氣。首先奪人眼球
的是那隻熟透了的桃子；一旁的三隻石榴各具形
態，其中一隻鼓脹欲裂，熟透了的石榴籽被勾成
方形顆粒，分明與現實迥然有異，卻給人以真實
的立體感。桃葉較大，以焦墨勾葉脈；石榴葉較
小，以沒骨寫成。左下角一隻蜻蜓款款而飛，從
其精緻入微的用筆來看，當是夙構，而整幅畫卻
給人以一氣呵成之感。款題以夭桃寓長壽，以石
榴寓多子，反映了老人對世人世情的一種良好願
望。從起首鈐以"吾草木眾人也"、用巨印"人
長壽"壓角來看，顯見老人對這位來自家鄉的世
侄之禮遇，畫中無疑寄寓了那一份對家鄉及親友
的祝福。

荔枝圖　　水墨、宣紙
　　　　　　68×33.5cm　1942年

款題：白石老人八十二歲時之作
印章：齊大（朱文）

　　　盛產於南國的荔枝素有"果中之王"的美譽，馥郁香甜歷來
為人們所喜愛。其枝葉與果實色澤濃豔、對比強烈，加之"荔"
與"利"諧音，二者能構成觀賞性愉悅與吉祥語祈願的雙重審美
效應，因而常常受到畫家的親睞。荔枝是齊白石花鳥畫中習見的
題材之一。老人早年三至廣東，曾有過"纖手教儂剝荔枝"的豔
遇；晚年還時常念及當年的南國之遊，他有一首七絕《思食荔枝》
歎道："此生無計作重遊，五月垂丹勝鶴頭。為口不辭勞跋涉，
願風吹我到欽州。"齊白石畫荔枝，或垂掛，或籃提，構圖形式
不拘。嘗見齊氏所繪一套規格極小（僅為十餘公分見方）的花鳥
冊頁，其中一幀畫荔枝四顆，無枝葉，款徑題曰"四利"。此幅提
籃荔枝圖作於一九四二年。

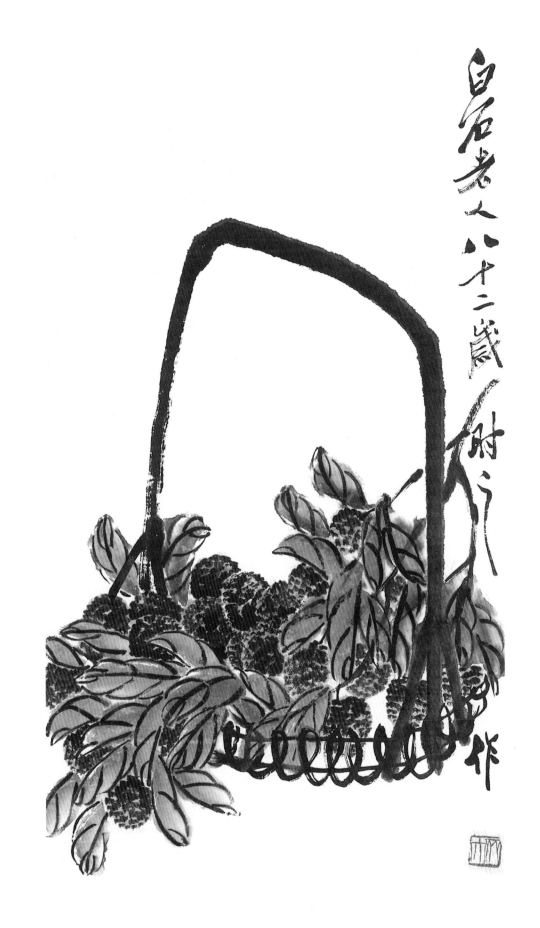

白石老人八十二歲附汾作

荷花圖　　水墨、宣紙
　　　　　　67.5×33.5cm　1948年

款題：八十八歲白石　戊子
印章：白石翁（朱文）

　　湘潭白石鋪星塘老屋前面長年有碧水一泓，叫星斗塘。每逢入夏，荷葉田田，荷花飄香。齊白石定居北京後，記憶中那滿塘荷花的光景幾乎成了他鄉情的寄託與象徵。當他決心告別冷逸畫風，矢志變法，古人詩中那“連天碧”、“別樣紅”的境界與濃濃的鄉情使他很容易從荷花找到突破口，於是，老人筆下的荷花成為了“紅花墨葉”的典型圖式之一。我們看老人畫於一九四八年的這件作品：大筆揮就的荷葉，墨色濃淡相生；上下點綴的小荷葉，姿態各異；紅色的花瓣、黃色的蓮蓬、黑色的花蕊，鮮豔欲滴；碩大的荷花將荷梗壓彎，仿佛能看到花在搖曳，一時畫面也就有了動感。雖屬成型的圖式，而每一張又有不同，正如老人在另一幅荷花上題款所云：“一花一葉掃凡胎，墨色靈光五色開。”

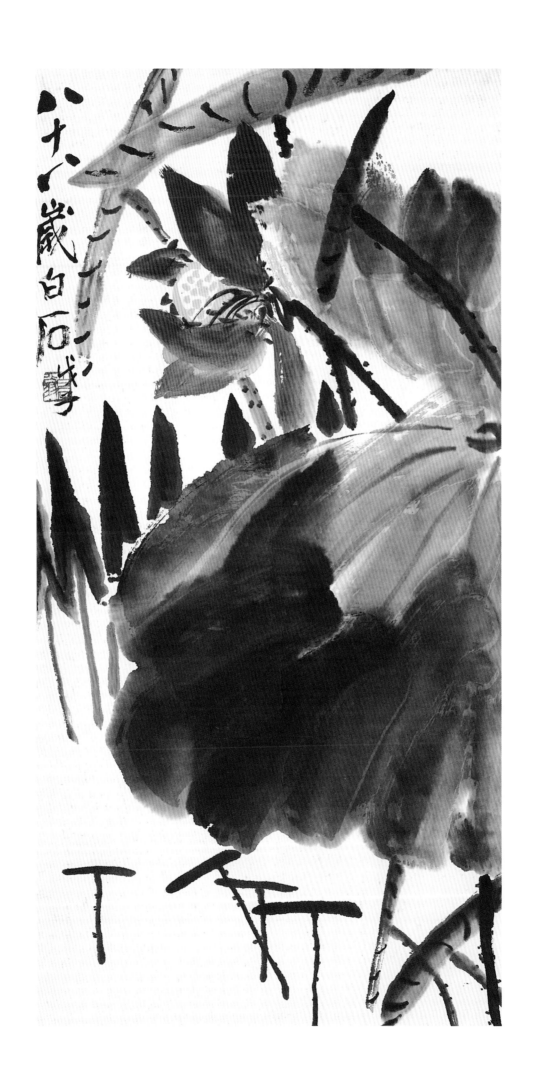

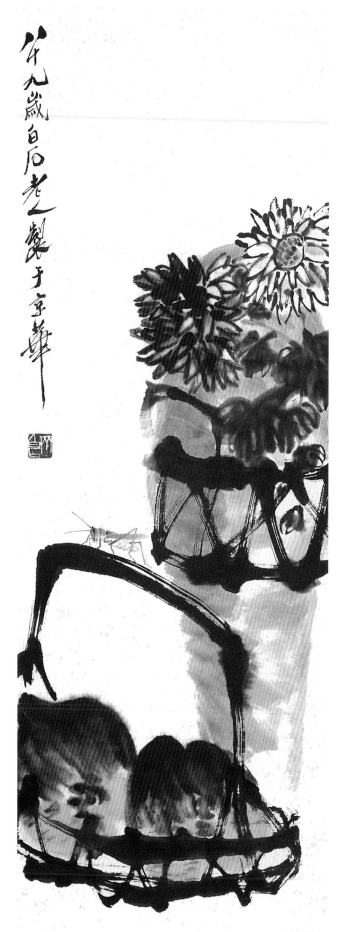

菊壽圖　　　水墨、宣紙
　　　　　　100×34cm　1951年

坐1949

款題：八十九歲 白石老人製于京華
印章：齊白石（白文）　歸夢看池魚（朱文）

　　壽桃、菊花、酒罈、螞蚱，是白石老人常畫的題材。看到這畫，讓人立刻想到另一個喜歡畫這類題材的畫家：吳昌碩。從這幅畫的畫面上，可以明顯地看到"海派"在白石老人身上的影響，更確切地說，是看到吳昌碩對白石老人的影響。如果將白石老人的這類作品和吳昌碩的做一比較，我們就會發現他們之間一致的地方，比如壽桃、菊花的畫法、設色等等。所不同的是在氣息上。吳昌碩的畫文人氣息重，白石老人的比較生猛，尤其是盛桃的竹藍和酒罈的提梁，那幾下子真是挺"拽"的，特別見白石的線味，自然，視角上的張力和鄉野氣息便要彰顯許多。由此可見，學歸學，影響歸影響，氣息上的東西是骨子裏的，藏也藏不住，也奈它不何。白石老人之過人處，這庶乎是其中至要的一點。

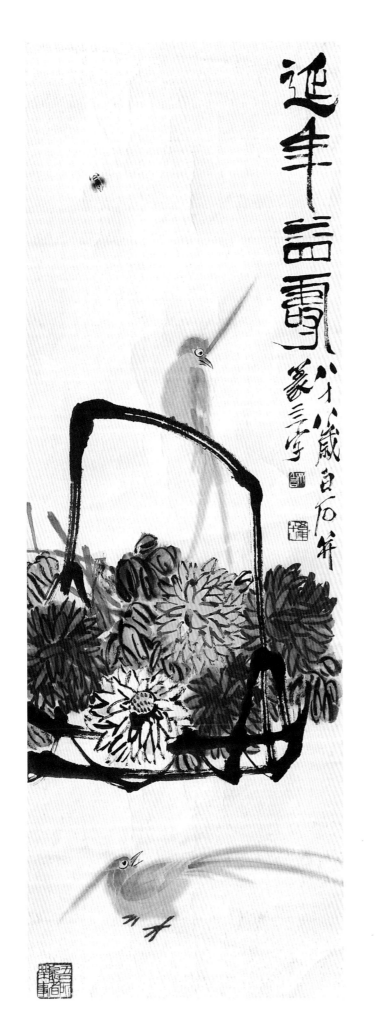

延年益壽圖　　水墨、宣紙
103×34cm　1948年

款題：延年益壽（篆）　八十八歲白石　並篆四字
印章：齊白石（白文）　吾年八十八（朱文）
　　　吾所能者樂事（朱文）

　　生命是人類永恆的話題。在這幅畫裏，老人用以表現和祈祝生命的，是畫了一藍盛開的秋菊、兩隻綬帶鳥和一隻振翅鳴飛的蜜蜂。"綬"與"壽"諧音，藉以點題。白石老人真是了不起，用寥寥數物就把一個沉重而纏人的問題講清楚了，我們不得不佩服白石老人的本事。這幅畫在構圖上的匠心，當在於對兩隻綬帶鳥的安排上，一隻棲於竹藍的提手，另一隻蹦跳於竹藍前面的地上，而它們的目光則集中於畫外的某一點。那一"點"是什麼呢？你可以想像是趕來湊趣的它們的另一些夥伴（興許還是情敵），或者是又來了一幫祝壽的親友，抑或…總之，由你去想。幽默而充滿童心的白石老人，在這裏，可說輕輕鬆鬆、毫不著意就吊了一下我們的胃口。人淡如菊，興許便是延年益壽的秘訣，只是，往往要走到生命的半山腰後才悟得。作這幅畫時白石老人已八十八歲，他把這個生命的奧秘溫婉地告訴了後來人，可惜很多讀畫者忽視了老人這個忠告，所以沒有像他那樣成為生命競賽的奪冠者。

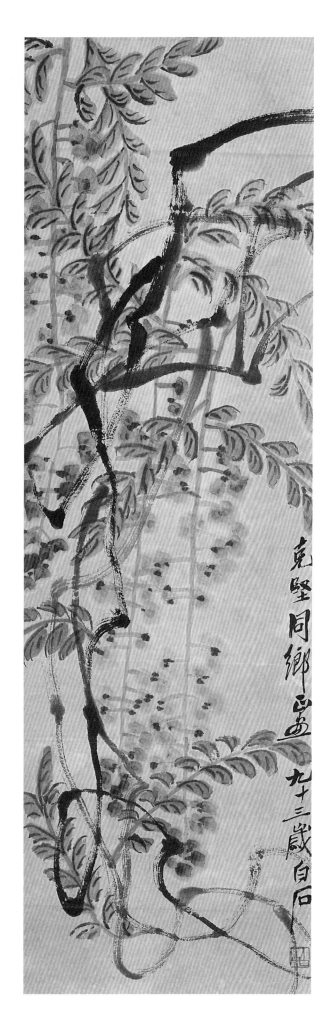

紫藤　　　水墨、宣紙
　　　　　104×32.5cm　1953年

款題：克堅同鄉正畫。九十三歲白石。
印章：白石（朱文）。

　　每個傑出的藝術家，內心都有著他的秘密，背景不同，秘密也不同。齊白石的氣脈更接近鄉村，所以他的畫平易家常，即使不是畫的鄉土生活，也透著山人的淳樸，洋溢出一種充滿生活趣味的鮮活，讓人覺得這樣的畫是親切的、可以接近的，甚或勾起某段生活的記憶。這種鮮活，源於齊白石的童心，源於他對日常生活沒有隔閡的直率的歡喜心。讀他的畫，也就像看到老人一臉的開心，仿佛這些情致就在身邊，我們自己也跟著無限地歡喜起來。眼前這幅《紫藤》，葉子上下錯落擺放，看上去變化不大，花亦靜垂，但葉脈通氣，紅英嫵媚，靠的什麼？就是那幾根狂恣不羈的藤枝。纏繞在花葉間的藤枝，接納著陽光，也接納著雨露，更聯絡著葉脈與花朵的感情，於是我們眼前便彰顯出一個大美的氣象、一個雲卷雲舒風雲自在的境界。這是老人童真的流露。老人筆下的花草蟲魚，無不充滿熱情、充滿力量、充滿欲望，即便恬淡也是有溫度的。誠如是，他的畫便溝通了世俗與文人之間的審美情趣，老百姓看得懂，覺得他不玩虛的；文人呢，也喜歡他的化普通為審美的生動。藝術是不可複製的，齊白石就是齊白石。一位老人可愛又有童心是一種人氣，有了這種氣，便有了白石的藝術。

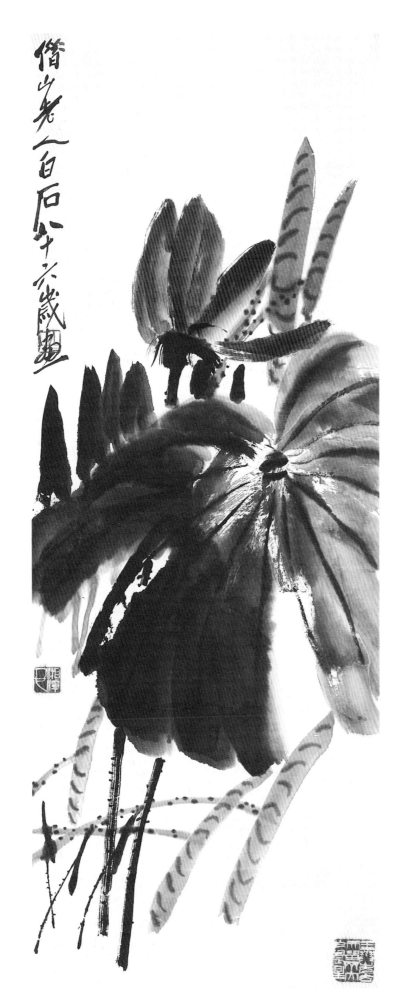

荷花圖　　水墨、宣紙
97×35.5cm　1946年

款題：借山老人八十六歲畫
印章：白石（朱文）　湘潭人也（白文）　王樊
　　　先去天留齊大作晨星（白文）

　　此幅《荷花圖》下筆輕快歡暢，一氣呵成，
著色濃重溫潤，層次分明，為典型的紅花墨葉
法；其精妙之處尤在畫面的構成處理。其一，大
葉與小葉、葉與莖、葉與花的關係處理：疏密、
濃淡、欹側、開合、虛實、剛柔，無不信手拈來
而恰到好處。其二，彩與墨的關係處理：萬綠叢
中一點紅雖是至景，但真正只有「一點」時，便
覺單調。老人高明之處，首先在於造「一朵」荷
花之險，然後以印章補之，補得有如天然，層次
頓生，畫外之意漸遠。

　　白石老人畫荷花，曾得「當面笑人，背面笑
人，倒也笑人，暗裏笑人」之態；也曾邀陳師曾
等好友為荷花慶生日，可見其對荷花情有獨鍾。
人常言「畫為心聲」。老人是年在南京、上海等
地舉辦畫展，備受稱賞。此乃內心欣喜之作，人
當不笑我妄言也。

絲瓜　　水墨、宣紙
69×40.5cm　1952年

款題：懷明同志正畫　壬辰　九十二歲白石
印章：齊白石（白文）

　　每次看白石老人的畫，心中總會湧上無限的歡喜。歡喜看他畫畫的疏密張弛，歡喜看他宣紙上仿佛嬝娜起荷香，甚至聽到飛向藤蘿的蜜蜂嗡嗡，還有那兩隻黃綠相間的鴛鴦在荷葉下說著什麼悄悄話⋯，白石老人的感情與鄉村、土地、生活須臾不曾分離。一些傳統繪畫中似乎不登大雅之堂的素材，一經老人的情感揮寫，中國畫的天地頓時開闊許多。水墨與色彩的渲染，使他的畫充溢著土地的質樸與活潑的生機。譬如眼前這幅《絲瓜圖》，幾抹墨葉，幾竿竹架，幾根藤蔓，幾條絲瓜，仿佛不經意間的筆墨，就使一片蔬翠瓜鮮的農家菜園小景活現在眼前。瓜葉間的幾簇黃花，是畫面上的鮮亮，更是老人心裏的熱，在把老人的情懷點燃。也許畫面上的這個情景，是童年阿芝的生活日常，驀然從記憶深處灑落在宣紙上，抑或是客居京華的九十二歲老人，藉此在抒寫他情繞魂牽的思鄉夢。是的，草馥泥芳的故鄉是白石老人一生的牽掛，也是他一生的滋養。不由得度及老人那一顆"望白石家山難舍"的心，到老，這顆心依然如他的一張山水畫中那一葉扁舟，在遙望紅日自渺遠的水天一線昇起。

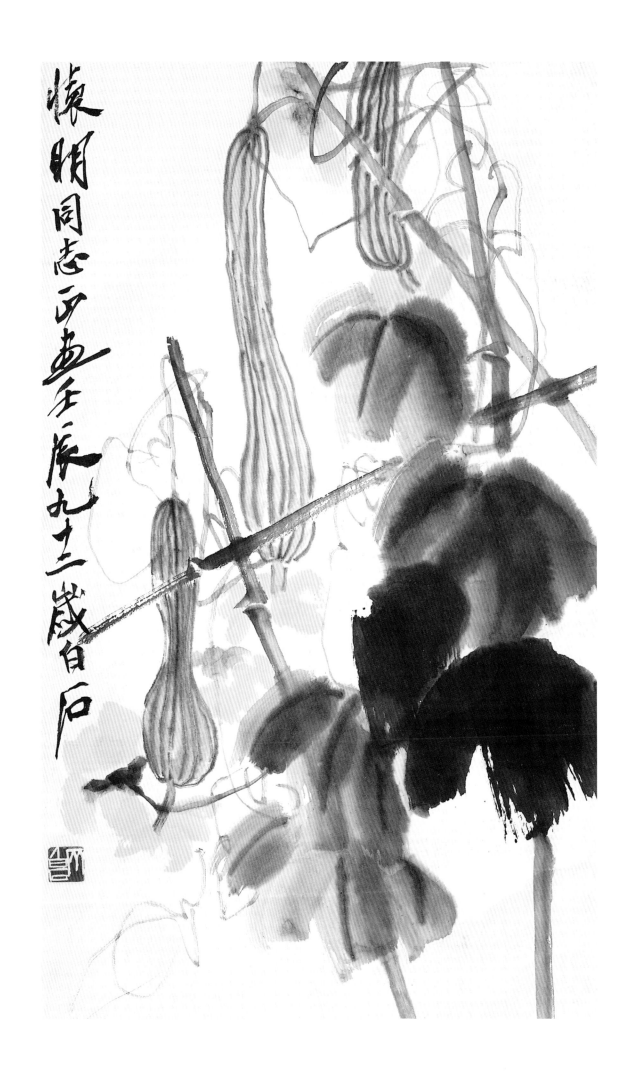

焕明同志正画壬辰九十二歲齊白石

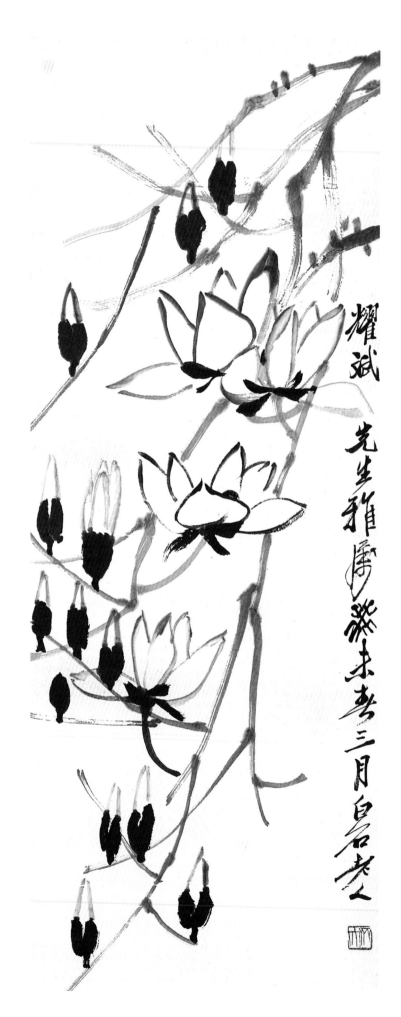

玉蘭圖　水墨、宣紙
104×34cm　1943年

款題：耀斌先生雅屬　癸未春三月　白石老人
印章：齊大（朱文）

　　齊白石喜歡畫玉蘭，一是因其"入室亦聞香"，二是因其"草木知春君最先"。曾有詠玉蘭詩："春風未暖椏枝斜，雨水初乾正著葩。桃李未開梅已過，人間只此玉蘭花。"表達了這種情感。

　　此幅《玉蘭圖》，純以線寫出，潤而挺、枯而健的長線，爽而利、濃而聚的短線，縱橫交織，疏密穿插，卻又走勢明確。齊白石作畫，於位置的經營常三思難定，一旦落筆，卻又流暢從容。這種如風之線時而中鋒，時而側鋒，時而中側互用，雖出於應酬，但他獨有的線條風格和運行節奏仍能讓觀者的情感隨著作者筆毫的跳動而飛舞翩然。

　　齊白石對線條曾有精闢的論述："作畫須有筆力，方能使觀者快心。凡苦言中鋒使筆，實無才氣之流也。"以此語驗之此圖，信然。

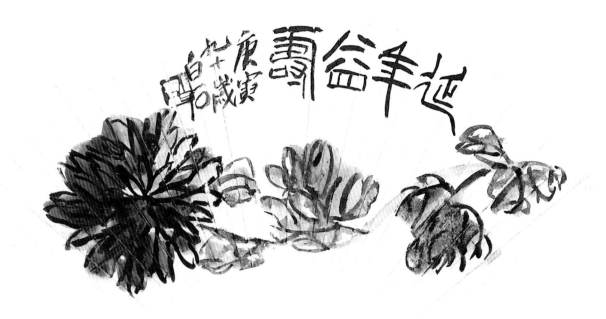

延年益壽　　　水墨、宣紙
　　　　　　　54.5×19.8cm　1950年

款題：延年益壽（篆）　庚寅九十歲白石
印章：白石（朱文）

　　藝術靠什麼傳？主要靠"感"來傳。這就需要搞藝術的人首先自己敏感，然後再有手段把自己的"感"傳給別人。齊白石是非常敏感的。在這幅畫中，我們可以看到，齊白石找到一個極好的傳感方法，這就是"寫"。其實，早在元代，文人就已經將"寫"和"感"融會貫通了。遺憾的是後來社會的主流意識被概念化、程式化、簡單重複所取代，畫畫的似乎就不再"傳"、不再"感"了，而變成了什麼什麼"描"、什麼"皴"。齊白石大筆一揮，接通了斷了氣的兩頭，此路一通，一代生機勃勃的新畫風就開始了，從此"寫"不僅再次成為傳感的重要手段，也使中國畫重新立於世界藝術之林。說穿了，"寫"就是一台"感測器"，不但可以把形、形式感充分表達，且還可以通過"感"把畫家的內心世界彰顯無遺。當"寫"到更自由階段時甚至能把潛意識也從心底裏挖掘出來。這一點，齊白石晚年也做到了。

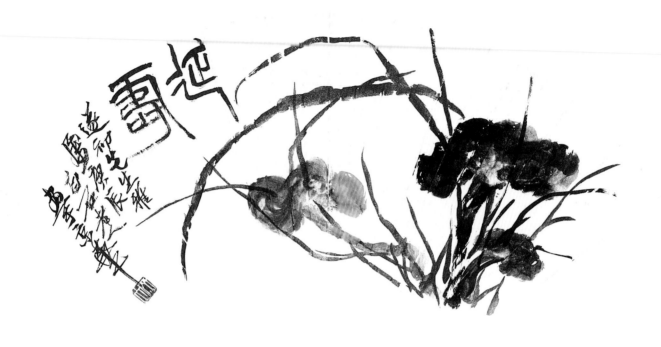

靈芝　　　水墨、宣紙
　　　　　54×19.8cm　1940年

款題：延壽（篆）　逐初先生雅屬　庚辰　白石老人畫于京華
印章：齊大（白文）

　　此幀靈芝蘭草扇面，雖為齊白石的應酬之作，卻展示出了作
者極高的藝術素養。由熟紙製成的扇面佈滿摺痕，創作時容易出
現用筆不暢而又線條流滑的弊病，他卻巧妙地利用了扇面的肌
理。細觀每一筆蘭草，姿態舒展，神情生動，特別是兩筆長葉，
自右向左盡勢送出，輕重相生，向肯適直，不但沒有流泅之弊，
自然出現的飛白，反而更顯凝練和渾厚，與左上方的篆書大字之
用筆有異曲同工之妙。大小、形態、色彩各異的三枝靈芝，兩密
一疏，兩正一斜，與蘭草一同形成向上、向左的延展之勢，順此
延展之勢，作者餘左上方的空白之處，首先題以 "延壽" 兩個篆
書大字，接著又四行行書小字，最後鈐上一方紅色的白文印，不
僅使視覺中心集中於一處，題詞的寓意凸現，更使整個畫面前後
呼應，形成了強烈的疏密對比。這種密集中透著空靈，沉實中蘊
含瀟灑的表現手法，看似信手拈來，實則匠心獨運。

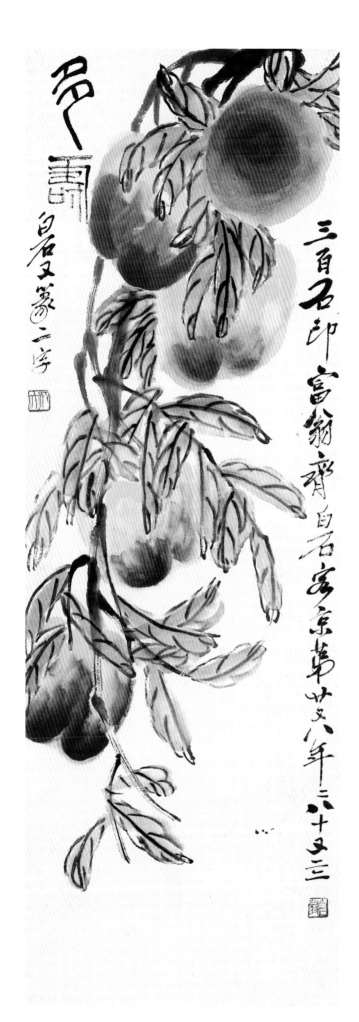

多壽　　水墨、宣紙
　　　　100×34cm　1944年

款題：三百石印富翁齊白石　客京華第廿又八
　　　年　年八十又四　多壽（篆）白石又篆
　　　二字
印章：白石翁（朱文）齊大（朱文）

　　幾個世人見慣的桃子，到了齊白石手裏，
居然變得碩大如球、如缸，且如此鮮活、氣象，
使人頓生熱情，長記心上。這應歸到老人過人的
敏感與膽識。可以說，老人一輩子憑著他的敏
感，鑄就了他的藝術感覺；藉著他的膽識，使他
衝破了許多樊籬，從而成就了他的畫、印、書、
詩。說起來，這種敏感和膽識，其實我們每個人
都曾有過，那就是童心，只不過逝去得太早，再
加上"科學"和書本幾乎修正泯滅掉我們的天
真，而當自己偶或出現真實的敏感和沒有被污染
的童心時，我們反而沒有了膽量，甚至不敢相信
自己了。可貴的是，齊白石一輩子都忠於自己的
感受，所以他有著驚人的膽識。在這幅畫裏，白
石老人動用了"寫"、"野"、"疊"、"破"、
"隨意改變倍數"等諸多因素，把這麼多潛意識
壓縮在一個小小的平面裏，於是潛意識的
"堆"裏就顯出一個"真"字來。我們不得不佩
服老人的膽識，就在他過世已經半個多世紀的今
天，我們仍能通過畫面感受到老人傳遞給我們的
生命感，而且這種真實的生命感還將隨著時間的
推移，一代一代傳下去。

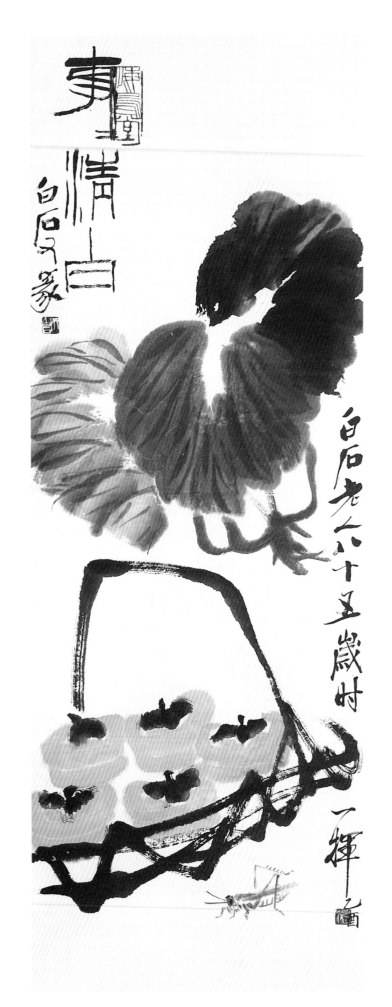

白菜柿子圖　　水墨、宣紙
96×34cm　1945年

款題：白石老人八十五歲時一揮　乙酉　事事清
　　　白　白石又篆
印章：借山翁（白文）　悔烏堂（朱文）
　　　齊白石（白文）

　　白菜、柿子、蟋蟀，鄉村尋常物也。是畫作
於一九四五年，時白石老人客京華。七月初七日
（國曆八月十四日），日本宣告無條件投降，深受
八年淪陷之苦的白石老人，聞訊後興奮異常，徹
夜未眠。自此，老人恢復賣畫刻印直至謝世。
　　齊白石語於胡絜青諸門人曰："我絕不畫我
沒見過的東西。"何故？老人自傳中有答案：
"說話要說人家聽得懂的話，畫畫要畫人家看見
過的東西。概言之，既不欺人，亦不自欺。"老
人　工作畫以勤萬引，所繪皆為熟悉物象。正所
謂為萬蟲寫照，替百鳥傳神。
　　齊白石有論畫語云："既要工，又要寫，最
難把握。"又云："歷來畫家所謂'畫人莫畫
手'；余謂畫蟲之腳亦不易好，非捉蟲寫生不能
有如此之工。"此圖白菜潑墨豪邁，柿子傳神簡
練，蟋蟀足部纖毫畢見，栩栩如生；令人嘆服
處：其工中有寫，寫中見精微，堪稱精心之作！

48

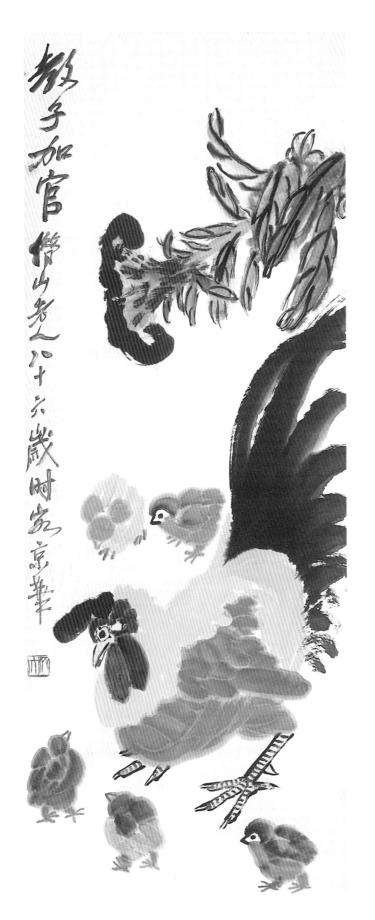

雞冠花群雞

水墨、宣紙
99.5×33.5cm　1946年

款題：教子加官　借山老人八十六歲　時客京華
印章：齊大（朱文）　魯班門下（白文）

　　齊白石曾與胡橐語云："我對雞仔細觀察和研究的時間比畫雞的時間多得多，所以才能有神。"又云："正看著東西的動物，眼睛最難畫，一定要叫它真看到才行。"這兩句樸質的大白話，含意頗深：要摹寫物象，必要深研物象，抓住物象奪人心魄的特徵，方能使物象形神兼備。言淺意遠，寄託遙深，齊白石之所以為齊白石也！

　　往日昂首挺立、威風八面的公雞，何以在此畫中俯身下蹲？雞群上方的一枝雞冠花說明了問題：父親在諄諄教誨著他的孩子們，難怪眼神還充滿著慈祥與關愛。而小雞或低頭覓食，或躑躅前行，眼神稚嫩，憨態可掬。

　　"冠"者，"官"之諧音也。教子加"官"是否深含老人的望子成龍之意？定居舊京多年，猶言"時客京華"，此一"客"字是否深藏思鄉之情？願讀者諸君察之。

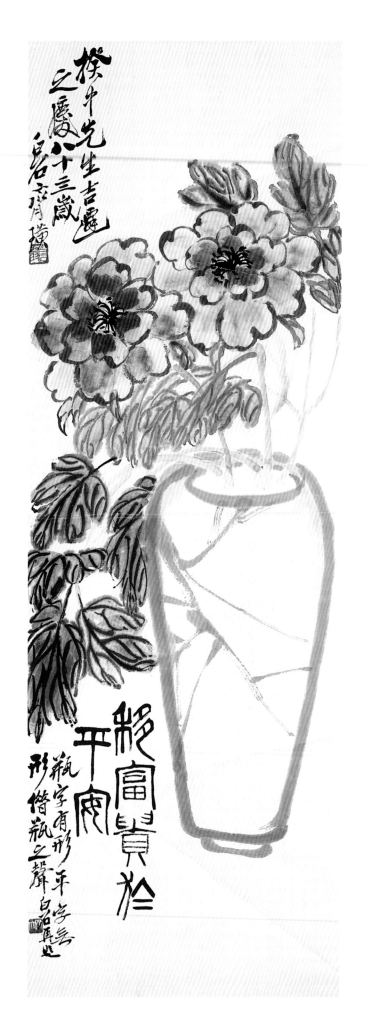

牡丹花瓶　　　　水墨、宣紙
　　　　　　　　103×34.5cm　1944年

款題：揆中先生 吉遷之慶　八十四歲白石齊璜
　　　移富貴 於平安（篆）　瓶字有形 平字無形
　　　借瓶之聲　白石再題
印章：白石翁（朱文）　齊大（白文）

　　牡丹者，富貴也；花瓶者，平安也。此畫作
於一九四四年。是年春，日軍發動豫、湘、桂戰
役，河南、湖南、廣西、廣東、福建大部分和貴
州的一部分淪陷。閏四月十七日（國曆六月十七
日），齊白石家鄉湘潭淪陷。老人作《群鼠圖》
刺之。又有題蟹詩云：「處處草泥鄉，行到何方
好；去歲見君多，今歲見君少。」諷喻侵略者不
得善終。嶔崎磊落之才，高風亮節之氣，足使藝
林生光。而朋友喬遷，老人作牡丹與花瓶祝福友
人移富貴於平安，見其對友人之殷殷誠心與拳拳
美意，這在戰亂之秋尤足珍貴。
　　此圖花瓶概括，牡丹層層累累，花葉爛漫天
真，花蕊兼工帶寫。誠如齊白石與胡佩衡論畫
語：「作畫當粗中帶細，細裏有寫。」
　　齊白石有題牡丹詩曰：「衣上黃沙萬斛，塚
中破筆千支。至死無聞人世，只因不買胭脂。」
又云：「古人說，行萬里路，讀萬卷書，我看還
要有萬擔稿才行。」老人九十六歲高齡仍繪牡丹
不倦，足可見其成功非唯天資奇高，勤奮尤為人
所不及。

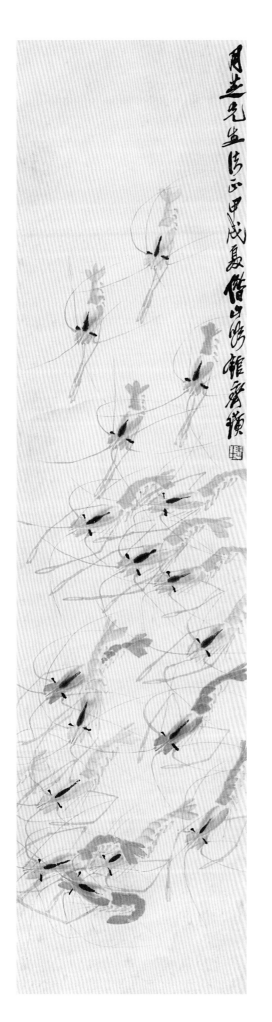

群蝦圖　　水墨、宣紙
　　　　　　138×35cm　1934年

款題：月芝先生 法正　甲戌夏　借山吟館齊璜
印章：老木（朱文）

　　此畫作於一九三四年。齊白石年輕時即畫蝦。初，亦步亦趨，接踵前人，至五十歲仍不足觀。一九二五年，齊白石六十三歲，贈《群蝦圖》與胡佩衡，自詡始有氣象，可以示人。此後數十載寒暑，畫蝦不斷，五變其法，遂見齊家風貌。由此可知：咬住物象，反覆揣摩，不斷實踐，方能有成。這是齊白石留給我們通向成功的金鑰匙。

　　齊白石嘗語胡橐曰：〝余畫蝦幾十年始得其神。〞又云：〝我畫的蝦和平常看見的蝦不一樣，我追求的不是形似，而是神似。所以，畫出蝦來是活的。〞這兩句話有助於理解齊白石〝妙在似與不似之間〞一語：似者，似其神也，神必似；不似者，不必似其形也，形可似，卻無須拘泥。神為熊掌形為魚，二者不可得兼，遺貌而取神。大氣魄！大手筆！

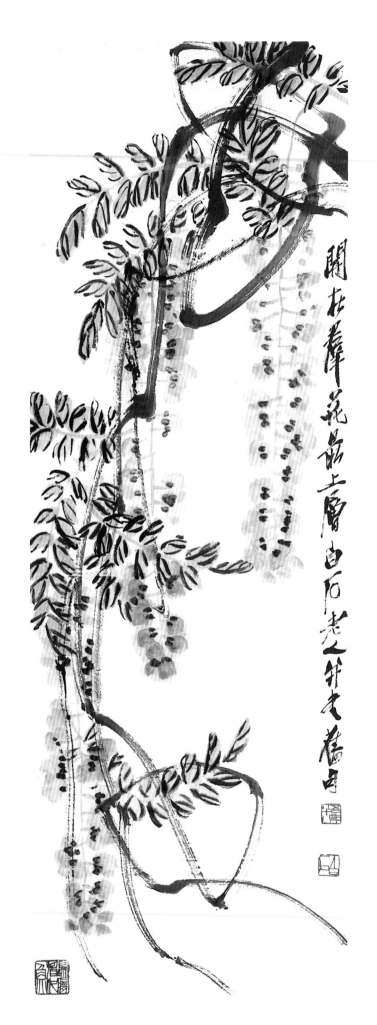

紫藤　　　　水墨、宣紙
　　　　　　100×34cm　1948年

款題：開在群花最上層　白石老人並書舊句
印章：吾年八十八（朱文）　白石（朱文）
　　　歸夢看池魚（朱文）

　　此幀《紫藤》無年款，據印文可知作於一九四八年。是年遼瀋、淮海、平津三大戰役爆發。友人勸齊白石出走臺灣，齊未允，留居北平。秋，法幣貶值，物價猛漲，國民政府發行"金圓券"，引發通貨膨脹，有人用金圓券成百上千地訂購齊白石畫作，齊無奈掛出"暫停收件"的告白。

　　齊白石有論畫語云："作畫用筆不可太停勻，太停勻就見不出疾徐頓挫的趣味。該仔細處應當特別仔細，該放膽的地方也應當特別放膽。"又有論畫詩曰，"輕描大寫各勞神，受得師承見本真。八十老翁先論定，半如兒女半風雲（自注云：謂工者如兒女之有情致，粗者如風雲變幻不可捉摸也）。"

　　如果說上述論畫語與論畫詩為理論，則此畫視作實踐可也。紫藤花瓣花蕊，著意安排，精雕細琢中略見齊氏豪邁風神，可理解為有兒女情致之"工"；花葉飛動，生氣盎然，枝幹藤蔓，時如渴驥奔泉，時如擔夫爭道，乾裂秋風，潤含春雨，誠為風雲變幻不可捉摸之"粗"者。半如兒女半風雲，兒女風雲如此違而不犯，和而不同，相得益彰，實為齊白石高妙處。

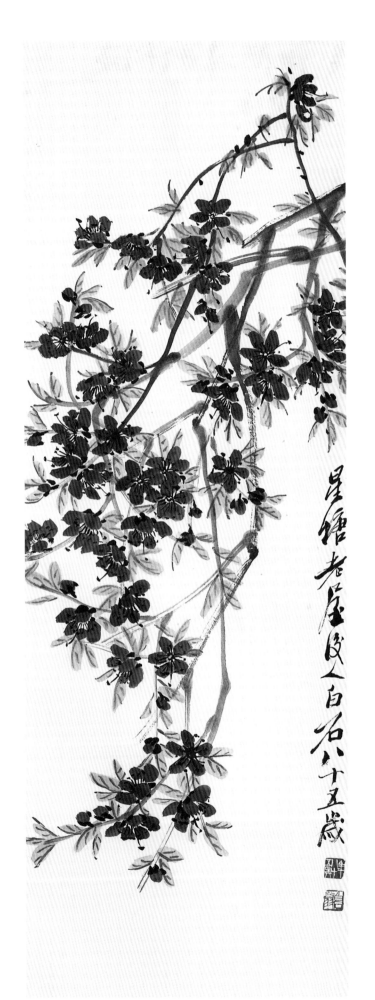

桃花　　水墨、宣紙
97×34cm　1945年

款題：星塘老屋後人　白石八十五歲
印章：年八十五矣（白文）　白石翁（朱文）

　　此畫作於一九四五年。是年八月，抗戰勝利，國共"雙十協定"發表。北平琉璃廠一帶的南紙店又掛出了齊白石的潤格。老人有答胡佩衡詩云："鐵柵三間屋，筆如農器忙；硯田牛未歇，落日照東廂。"又有題畫記云："昨日大風雨，心緒不寧，不曾作畫，今朝製此補充之，不教一日閒過也。"

　　桃為尋常果木，遍及大江南北，齊白石有感賦詩《新桃花》云："去歲葉無痕，今春花又新，誰云君命薄，我輩不如君。"慨歎世事如萍，人生如寄，莫如桃花般春去春會來，花謝花會再開。讀之令人唏噓不已。

　　此幀《桃花》純以沒骨法出之，本無可饒舌。若談畫不止於畫，於畫外思之，則旨意頗多。自陶淵明《桃花源記》始，桃花便有寧靜、和平、幸福之寓，齊白石歷八年淪陷，深知戰亂貽禍甚深，盼望玉宇澄清，家國太平。最是款識透出消息－星塘老屋後人。白石老人撚筆展紙之際，是否憑窗遠眺家山，又看到故鄉山頭那株年年綻放的小桃紅呢？

蝦 水墨、宣紙
51×19cm　1928年

款題：戊辰春三月　齊璜白石為子衡先生畫
　　　時居燕京第十二年也
印章：木人（朱文）　老白（白文）

　　蝦，在一扇面之上是解讀齊白石繪畫的一扇窗戶，也是白石老人的一塊"試驗田"。他是把從畫蝦上得到的經驗擴展到整個繪畫中，才登上了"似與不似之間"的境界。老人創作一生，從未安分過，直到晚年，還在做畫蝦的實驗，他筆下的蝦平添了成倍的生猛，讓我們找到了蝦的新感覺，而且通過蝦對人似乎都有了新的理解，人的精神與蝦的"精氣神"在某一點上重合了，並看到了畫裏滲透進的東西、筆墨本身的含量以及主觀的感受一步一步地更加多了。這時候，舉凡建立在公共批評之上的辭彙，如思想、文化、理性等等，統統只能讓路，留下的是：藝術家內心感情的傳達、人生體驗的傳達和物我之間關係的傳達。這樣的藝術再小，也會強大起來，因為這是藝術家構建的屬於他自己審美價值的家園，也是他生活與精神的故鄉。從齊白石的"試驗田"裏"寫"出來的、唯有中國的江河湖海田園才能孕育出來的蝦，以及這些蝦"說"的"話"，全世界操任何一種語言的人都可以"聽"得懂。

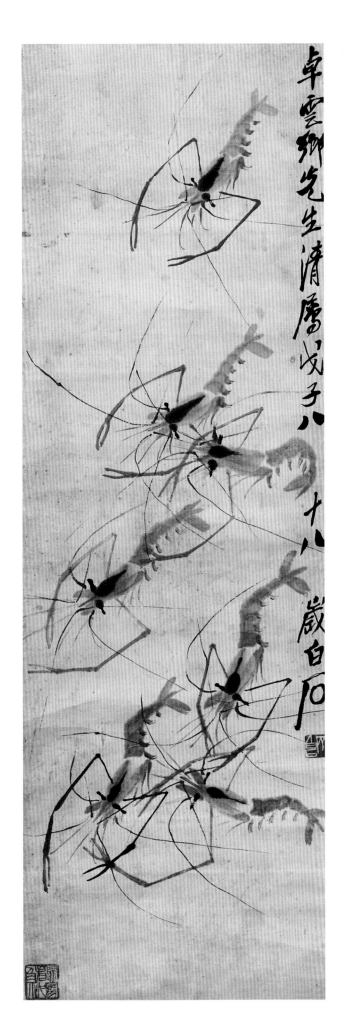

蝦　　水墨、宣紙
104×34cm　1948年

款題：卓雲鄉先生清屬　戊子八十八歲　白石
印章：齊白石（白文）　歸夢看池魚（朱文）

　　童年時代的齊白石好觀察和留心身邊的事物。他的母親和祖父帶他出入菜園、田地和池塘時，他就對周圍景象表現出濃厚興趣，甚至為某一處景物發呆。一次阿芝在池塘邊洗腳，他感覺到池塘裏有什麼東西輕輕地咬他的小腳丫，阿芝帶著疑惑的神情問一旁的祖父。祖父一邊樂，一邊回答：這是蝦兒在咬你的腳丫。阿芝鬧著要祖父給他撈上蝦來，祖父只好遂了孫兒的心願。蝦帶回家後用盆器養著，阿芝出神地看著蝦在水中遊動…。"蝦"是齊白石最早接觸的描繪對象之一，而且一輩子都愛蝦畫蝦，童年的趣事讓他與蝦結下了不解之緣。晚年的齊白石為了更好地表現蝦，常在家養蝦，琢磨蝦在水中游動的姿態，研究蝦的結構。白石老人早期所畫的蝦身為六節，晚年畫的則為五節。五節可能與中國的吉祥數有關，如"五子登科"、"五穀豐登"、"五福臨門"，就連他遠遊，也用上吉數"五出五歸"。此圖為老人一九四八年之作。七隻大蝦在水中游動，生動而富變化，有聚有散，墨色透明。蝦身於曲直中見彈性；蝦鬚尤見功力，神完氣足，流暢自如。

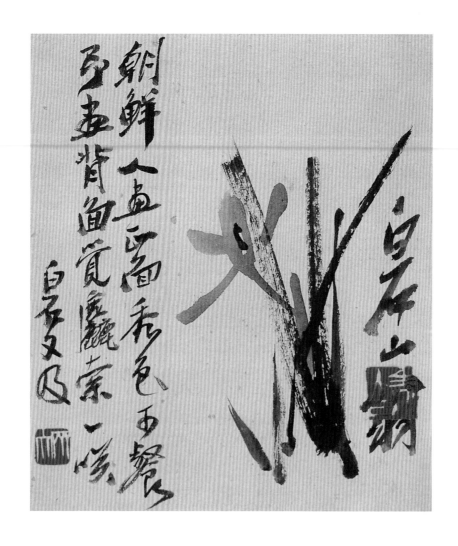

蘭花　　　水墨、宣紙
　　　　　20×18cm

款題：白石山翁　朝鮮人畫正面　秀色可餐
　　　予畫背面　覺齷齪　一笑　白石又及
印章：老白（白文）　齊大（白文）

　　　明清人畫蘭花多用行草筆法，以取陰柔沘美之氣，單朵蘭娟秀端
莊，叢蘭則顯得清狂狷狸。又有"喜寫芝蘭怒寫竹"之說，倡導以歡喜、
恬靜之創作心態畫蘭花。至吳昌碩、蒲華、齊白石、潘天壽四家，已是各
有突破、各具風采了。
　　　齊白石畫蘭，從《芥子園畫譜》入手，吸取了明清人及吳昌碩畫法
的長處，但更多的是對蘭寫生並進行了多種探索。隨著筆墨技巧的成熟，
他的蘭花畫出了自家風貌。此幅小品是在一張正面已由朝鮮人畫了一幅蘭
花的硬紙殼背面作畫的。寥寥數筆，似不經意，但看畫跋，又覺得是用心
之作。由此可見，齊白石每每以不同視角、不同思維去觀察、體味事物，
並嘗試從中獲得自己需要的東西。蘭花品種甚多，均可以入畫。此幀頁
冊，似為劍蘭，劍蘭花大，葉較寬而挺勁，較之其他品種柔軟的蘭葉，有
"粗"的感覺。此圖一花數葉，濃淡穿插，信手拈來。

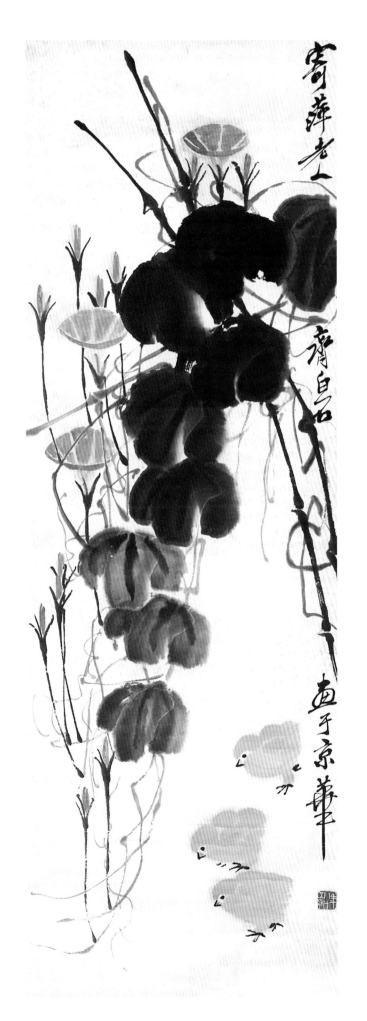

雛雞牽牛圖　　水墨、宣紙
1945年

款題：寄萍老人齊白石畫於京華
印章：年八十五矣（白文）

　　牽牛也是白石老人常畫的題材。老人喜歡畫
它，大概是欣賞牽牛花、蕾那種蓬勃向上的意態
和精神。細品這件《雛雞牽牛圖》，不難發現它
與老人的同類作品絕不雷同。首先是色彩的對
比：老人畫牽牛花，通常用洋紅，亦偶著絳、
紫；而此件的花、蕾卻施以花青。這一反常格的
"綠花墨葉"，大概是為了襯托花下那三隻黃生
生、毛茸茸的覓食小雞。另外，畫中勁健的竹
竿，或纏繞、或飄然下垂、穿插有致的藤蔓，富
有彈性、昂然向上的花枝…，全憑老人筆下那變
化無窮的線條賦予，老人用筆切切實實地賦予它
們以生命。此件為老人的畫作中為數不多的既不
落年款、又不鈐名章的作品之一，然而從畫上所
鈐唯一白文閒章得知，此畫作於一九四五年。

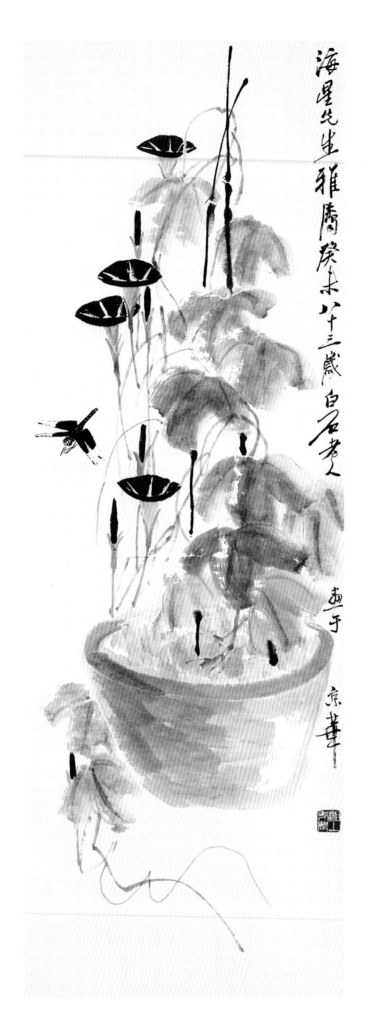

牽牛蜻蜓圖　　水墨、宣紙
　　　　　　　　1943年

款題：海星先生 雅屬　癸未八十三歲白石老人畫
　　　于京華
印章：湘上老農（白文）

　　齊白石自從在梅蘭芳家裏見過"花有極大
者過碗"的牽牛花之後，便"畫此大花，猶以為
小也"，此圖即為一證。
　　此幅牽牛之葉得一"簡"字。簡單寬闊的筆
觸，卻有豐富的變化。花則得一"繁"字。花形
的控制，花莖的留白，無不小心勾畫，卻利索簡
潔。藤則得一"寫"字。老人之線，不論粗細，
皆以筆寫之，故凝練厚重。而線之走向、穿插、
取勢又極分明，即使繁複如線團，細察之就能發
現其秩序井然。整體佈局又得一"適"字。缽、
化、藤、葉、竹架、蜻蜓，反款及鈐印，每一個
構成元素無不各居其所，恰到好處，多一點則
繁，移一處則亂。人皆言齊白石之長在於筆墨，
我則於筆墨之外，尤歡其佈局之妙。

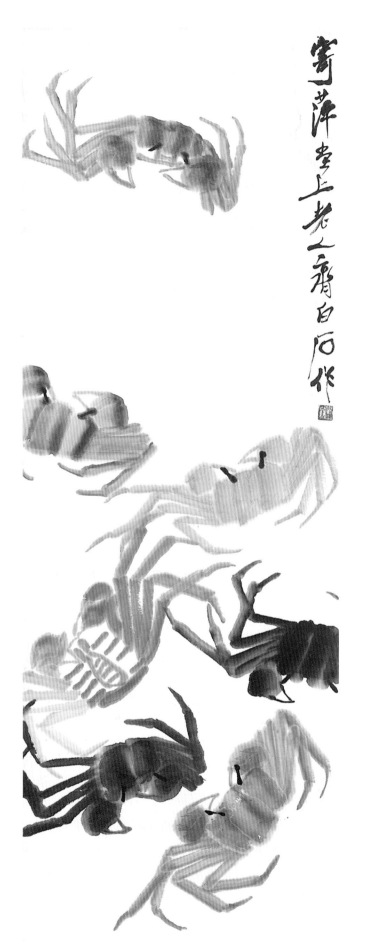

群蟹圖　　水墨、宣紙

款題：寄萍堂上老人齊白石作
印章：借山翁（白文）　歸夢看池魚（朱文）

　　世人皆知齊白石畫蝦為一絕，其實齊白石畫蟹同為一絕，而且畫蟹所花的時間，所投入的精力一點都不比畫蝦少。他曾題畫蟹云："余細觀九年，始得知蟹足行有規矩，左右有步伐。""余之畫蟹，七十歲以後一變，此又變也。"也正因為有九年的細觀，以及一變再變又變，如此圖之蟹不僅生趣盎然，似聞嬉戲中的滋滋聲，而且在其挺健、簡潔、一筆一摺的連續中，氣韻通貫，蟹殼的質感與蟹足的硬度和細毛給以人觸手可摸之感，令人歎為觀止。

　　豎幅群蟹，老人曾畫過多幅，每幅都有所不同。此幅一蟹居上，六蟹在下成群，雖有些擁擠，但由於濃淡、深淺、正反、穿插、方向的變化，以及將蟹身有意伸到畫外，強化了左右延伸之勢，加上款識和印章的縱向補充，使畫面形成了點線面縱橫開闔的巧妙組合，用老人自己的話說就是"無心為好而能好，則他人不能為也"，實為精品。

八百之壽　　水墨、宣紙

款題：八百之壽（篆）　白石
印章：齊大（白文）

　　八哥、柏樹，合起來就成了白石老人這幅畫的題識所云：八百之壽。這既是一幅壽慶圖，也是一段對生命之樹何以常青的形象詮釋。我則從這幅畫裏還讀到另兩個字：率性。早就聽過一種說法，說草書作畫是繪畫的至高境界。看了這幅畫才明白，草書作畫還是一種有我有法的境界，"隨興點染"才是更加自由的無我之境。白石老人在這幅畫裏，打破了他很長一段時間遵循的規矩和秩序，幾根枝幹落定，便大大小小深深淺淺一頓"點"去。白石老人的骨子裏定有一條顛覆的鏈，年輕時顛覆的形式是各種極致的"法"任我所用；中年時這條"鏈"上的環節是幽默、諷刺、不服、"犯壞"。隨著年齡和自信的增長，再沒有什麼條條框框能擋得住他的去路。他是在向繪畫藝術的規律挑戰，也是在向時代的局限挑戰，甚至是在向人這個物種敏感的極限挑戰。說白了，這種挑戰就是闖禁區的那種刺激，就是胡鬧裏那種自由的快樂。胡鬧是我們每個人都想試試的玩意，只不過有人藏在肚子裏不說，有時候敢說而不敢做，有的人敢做卻不敢給人看。而白石老人在繪畫上達到了無為無不為也無所謂的地步，於是為我們率性地胡鬧了一回，痛快！

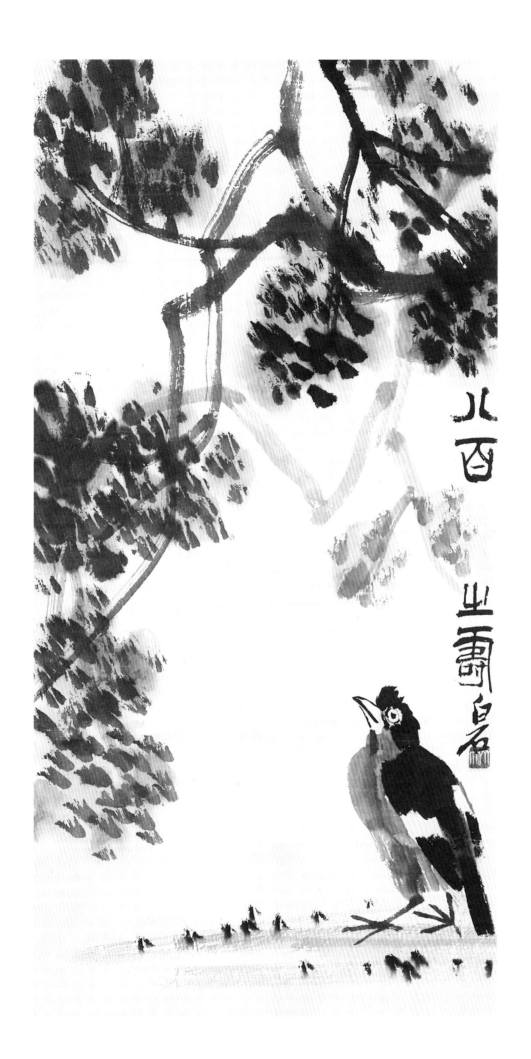

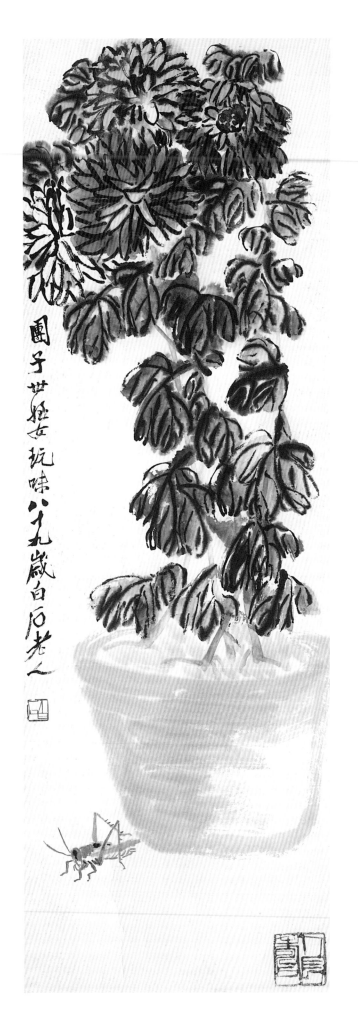

菊花秋蟲圖　　水墨、宣紙
　　　　　　　　　1949年

款題：團子世侄女玩味　八十九歲白石老人
印章：白石（朱文）　人長壽（朱文）

　　款題八十九歲，農曆時值己丑，國曆為一九四九年。白石老人心情歡暢，精神煥發，開始了他新的藝術生活。

　　菊者，花中四君子之一，以其深秋獨放，傲霜英姿，為歷代文人墨客不絕吟詠。白石老人愛菊，不唯一生畫菊不倦，亦有眾多詠菊詩為證。如"秋風容易到山家，且喜無錢酒可賒。醉倒籬邊勿歸去，此花開後更無花"；又"半年足不出柴門，屋角昨宵時有聲；晨起扶筇過籬落，菊花開到二三分"。

　　畫菊有墨、紅、黃、白之分。齊白石此畫紅菊一，黃菊一，白菊一，主次有致，錯落有序。葉脈淋漓恣肆，揮灑間有大氣魄；葉梗穿插渾然天成。猶有會心處：菊本靜者，蟲為動者；而老人筆下之菊婀娜搖曳，秋蟲卻於缽前凝神不前。靜中見動，動中寓靜。動耶？靜耶？動靜相生耶？唯白石老人知！

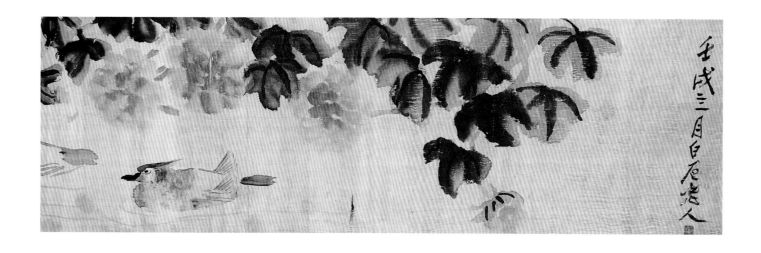

芙蓉鴛鴦　　水墨、宣紙
　　　　　　　1922年

款題：壬戌四月　白石老人
印章：白石翁（白文）

　　此畫作於一九二二年，齊白石六十歲，曾兩度奔走於京湘間。是年三月北上，值北伐戰爭，京漢路不通，滯留長沙，與張仲陽、楊重子、黎戩齋諸人過從，為黎戩齋畫鴛鴦芙蕖綾本橫幅，極精美。

　　此畫繪於帳檐之上，以沒骨法出之，花朵平中見奇，花葉參差錯落，兩鴛鴦一前一後追逐，頓使畫面開闊，令人生無窮之遐想。

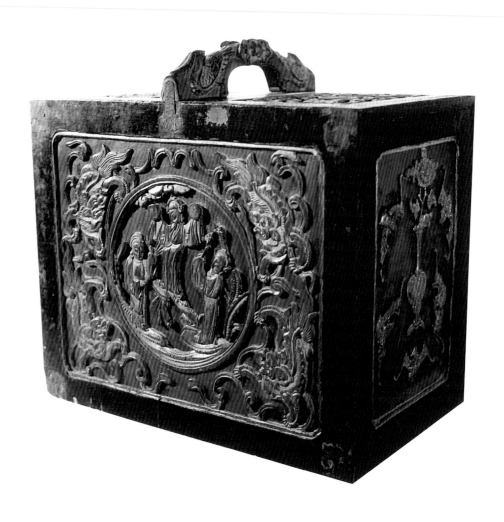

工具箱（木雕）　　木質浮雕　約 1882-1902年

35.4×22×28.5cm

　　齊白石木雕作品現存不多，可信度高的更少。這件雕花工具箱，原放在借山館齊白石家中，戰亂期間，被轉移至齊白石孫女家，躲過重重劫難，輾轉保存下來，彌足珍貴。此箱頂部提手雕成龍形，正面有四層抽屜。箱的四面塗黑、紅、黃三色漆，其中黑為底色，紅為雕刻紋飾之底色，雕刻紋飾本身為黃色。箱兩側雕刻有雲龍紋圍繞的吉祥人物"狀元及第"等，四角刻雄獅。圖像均為以平刀為主的薄肉雕，人物均為古裝立像，或正面，或正面頭、側面身，顧盼生動。頭的比例較大，臉方而寬，雕刻行刀呈斜勢，因之面部略見高低變化。從形制、結構及大小推測，此箱用於盛放較小的工具，如小雕刻刀與畫具等。

篆刻作品

一年容易又秋風

一別故人生百憂

一家多事

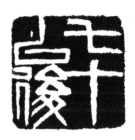

七十以後

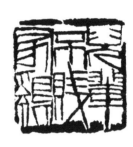

兒輩不賤家雞

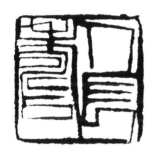

人長壽

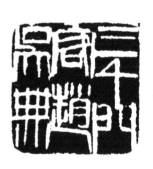

三千門客趙吳無

大匠之門

三百石印富翁

山姬帶病相扶持

也曾臥看牛山

五十以後始學填詞記

齊白石
藝術創作紀念展

66

雲臺

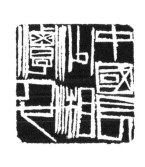

中國長沙湘潭人也

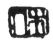

木人

木人

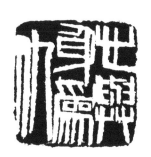

心與身為仇

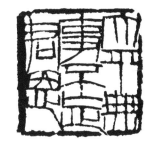

太平無事不忘君恩

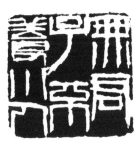

無君子不養小人

木居士

心耿耿

天涯亭過客

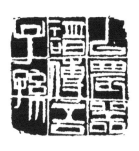

以農氣譜傳吾子孫

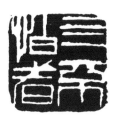

四不怕者

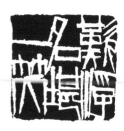

歎浮名堪一笑

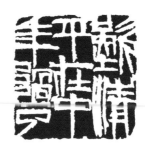

歎清平在中年過了

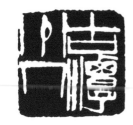

古潭州人

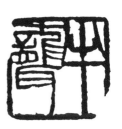

半聾

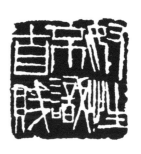

奴性不識直賤

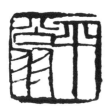

平翁

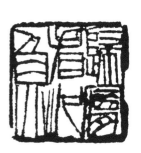

歸夢看池魚

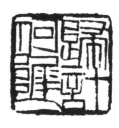

歸計何遲

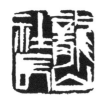

龍山社長

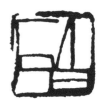

白石

白石白事

白石言事

白石叚看

齊大

白石草衣

白石曾觀

白石篆字

白石見

沖朋

年八十九

年八十六矣

年高身健不肯作神仙

有情者必工愁

有眼應識真偽

齊白石 藝術創作紀念展

老夫也在皮毛類

老手齊白石

老去無因啞且聾

老白

老白

老年肯如人意

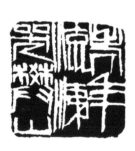

老年流涕哭樊山

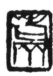

老齊

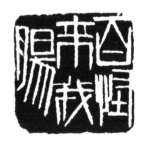

百怪來我腸

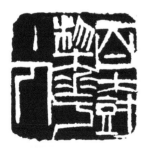

百樹梨花主人

行高于人眾必非也

老萍手段

老為兒曹作馬牛

老豈作鑼下獼猴

齊大

齊大

西山如笑笑我耶（邪）

西山雖在亦堪憐

西山風日思君

齊白石金石文字記

齊璜之印

齊璜印

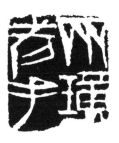

齊璜老手

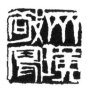

齊璜敬寫

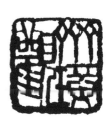

齊璜觀

齊頻生

何用余憂

何要浮名

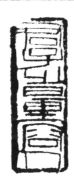

君子之量容人

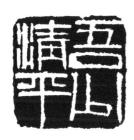

吾少清平

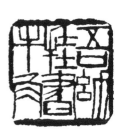

吾幼掛書牛角

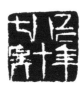

吾年八十八

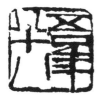

吾年八十七矣

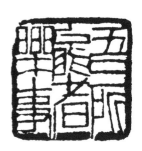

吾所能者樂事

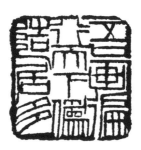

吾畫遍行天下偽造居多

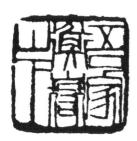

吾家衡嶽山下

吾草木眾人也

吾道何之

恐青山笑我今非昨

杏子隖老民

身健窮愁不須恥

佩鈴人

寶之子孫安得

宗磨

知己有恩

知我只有梅花

知足勝不祥

芷

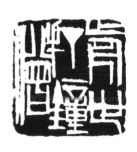

前世打鐘僧

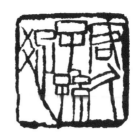

客久子孫疏

客久思鄉

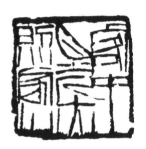

客中月光亦照家山

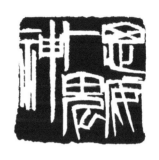

思安卜鬼神

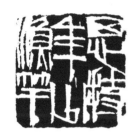

思持年少漁竿

恨翁

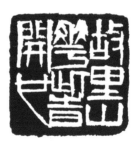

故里山花此時開也

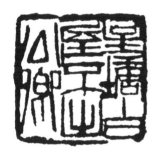

星塘白屋不出公卿

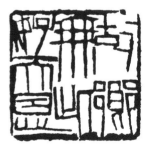

故鄉無此好天恩

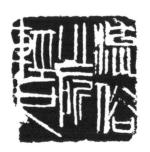

流俗少所輕也

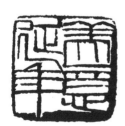

美意延年

苦吟一似寒蛩號

苹翁

借山主人

借山老子

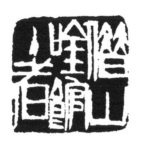

借山吟館主者

借山翁

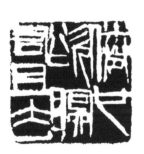

倦也欲眠君且去

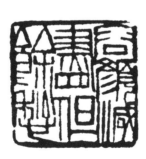

容顏減盡但餘愁

悔烏堂

蛩鳴無不平

鬼神使之非人工

強作風雅客

齊白石藝術創作紀念展

偶吟

寄萍堂

寂寞之道

接木移花手段

望白雲家山難捨

梨花小院

夢想芙蓉路八千

笠夫

郭殿丞

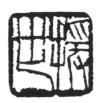

援世

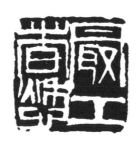

最工者愁

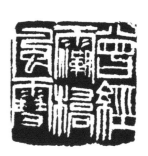

曾經瀟橋風雪

湘上老農

跛翁虎尾

痴思長繩繫日

隔花人遠天涯近

寡交因是非

宗翰

甑屋

為客負梨花

尋常百姓人家

豈辜負西山杜宇

憶（憎）君腸欲斷

慚愧世人知

賴漢

硯田農

窮後能詩

趙少昂

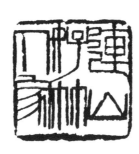

連山好竹人家

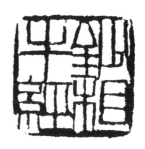

鈔相牛經

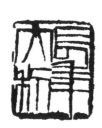

長年大利

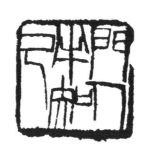

門人半知己

門人知己即恩人

閒散誤生平

頻生

風前月下清吟

飽看西山

餓叟

餘年離亂

魯班門下

尋思百計不如閒

煮畫庖

煮石

白石

小名阿芝

悔烏堂

一闋詞人

八硯樓

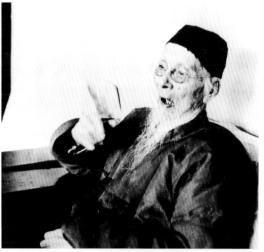

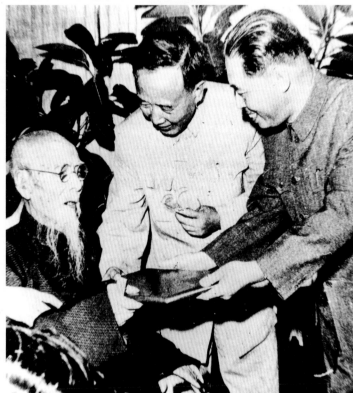

齊白石　生平年表

一八六四年	一月一日（農曆癸亥十一月二十二日） 生於湖南湘潭縣杏子塢星斗塘一個農民家庭。按生年即一歲的傳統計歲法，至甲子年稱二歲。 齊白石是家中長子，派名純芝，字渭清、蘭亭。
一八六六年	四歲　丙寅　同治五年 隨祖父齊萬秉識字。
一八七〇年	八歲　庚午　同治九年 從外祖父周雨若讀書，是年秋因病輟學。
一八七四年	十二歲　甲戌　同治十三年 三月九日，娶陳春君為童養媳。 六月十八日，祖父齊萬秉去世。
一八七七年	十五歲　丁丑　光緒三年 春天，拜本家叔祖齊仙佑為師，學粗木工，因體力弱小被辭退。後又改從齊長齡學粗木工。是年秋，決意改學細木工。
一八七八年	十六歲　戊寅　光緒四年 拜著名雕花木工周之美為師學藝。
一八八一年	十九歲　辛巳　光緒七年 周之美看其手藝學得很出色，准其出師。仍隨周之美在白石鋪方圓幾十里做木工。被人稱為“芝師傅”、“芝木匠”。
一八八二年	二十歲　壬午　光緒八年 得見《芥子園畫譜》，如獲至寶。 借回逐一勾影、染色，歷時半年才全部勾完，裝訂成十六冊。
一八八八年	二十六歲　戊子　光緒十四年 拜蕭薌陔為師，學畫肖像。後又向擅畫肖像的文少可學習。
一八八九年	二十七歲　己丑　光緒十五年 拜胡沁園、陳少蕃為師，學畫工筆花鳥草蟲，學詩文。 更名“璜”，號“瀕生”，別號“白石山人”。
八九〇年	二十八歲　庚寅　光緒十六年 在家鄉杏子塢、韶塘一帶為人畫像謀生。
一八九四年	三十二歲　甲午　光緒二十年 與王仲言、羅真吾、羅醒吾、陳茯根、譚子荃、胡立三藉五龍山大傑寺為址，成立“龍山詩社”。白石因年長被推為社長。
一八九六年	三十四歲　丙申　光緒二十二年 開始鑽研刻印。
一八九九年	三十七歲　己亥　光緒二十五年 正式拜王闓運為師習詩文。 自拓《寄園印存》四本。

一九○○年	三十八歲　庚子　光緒二十六年
	自星斗塘遷出，佃居蓮花峰下梅公祠，又在祠堂內擇一空地，自蓋一間書房，取名"借山吟館"。
一九○二年	四十歲　壬寅　光緒二十八年
	冬，應友人夏午詒之邀赴西安教畫。結識樊樊山。
	從這年起，筆法由工筆漸改爲大寫意。
一九○三年	四十一歲　癸卯　光緒二十九年
	初春，隨夏午詒全家啓程赴京。結識李筠庵等。開始臨寫魏碑。
	夏，取道天津，經上海回湘。這是他"五出五歸"中的第一次遠遊。
一九○四年	四十二歲　甲辰　光緒三十年
	春，遊江西。秋日返湘。此爲"五出五歸"中的第二次遠遊。歸家後改"借山吟館"爲"借山館"。
一九○五年	四十三歲　乙巳　光緒三十一年
	七月，應廣西提學使汪頌年之邀赴廣西，遊桂林山水。
一九○六年	四十四歲　丙午　光緒三十二年
	春節後不久，過梧州經廣東回家，此爲"五出五歸"中的第三次遠遊。歸家後買屋、置地，將房屋翻蓋一新，取名"寄萍堂"。又在堂內選一書室，將遠遊所得八塊硯石置於內，故名"八硯樓"。
一九○七年	四十五歲　丁未　光緒三十三年
	春天，再赴欽州做客。春夏間，小住肇慶，冬天回湘。此爲"五出五歸"中的第四次遠遊。
一九○八年	四十六歲　戊申　光緒三十四年
	應羅醒吾之邀到廣州。秋，回湘小住即返廣州。過年後（宣統元年）又去欽州。初夏，乘輪船經由香港去上海、蘇州。由南京經過江西歸故里。結束了"五出五歸"的遠遊生活。
	刻出第三本印譜，名《白石草衣金石刻畫》。
一九一○年	四十八歲　庚戌　宣統二年
	整理遠遊中的畫稿，繪《借山圖》。
一九一一年	四十九歲　辛亥　宣統三年
	春天，赴長沙請王闓運替祖母寫墓誌銘。
一九一二年	五十歲　壬子　民國元年
	山居。吟詩作畫。花鳥畫多取法八大山人、石濤、李復堂；草蟲寫生多工致，間或以寫意出之。取別號"萍翁"。
一九一七年	五十五歲　丁巳　民國六年
	五月，爲避家鄉兵匪之亂，隻身赴京。逢"張勳復辟"，轉赴天津避難。回京後住法源寺，結交陳師曾、淩直之、汪靄士、姚茫父、陳半丁、王夢白等人。

十月初返湘，家中之物已被洗劫一空，遂刻"丁巳劫灰之餘"印章以紀其事。

一九一九年	五十七歲　己未　民國八年

正月，再來北京，先寓居法源寺，後佃居龍泉寺附近，以賣畫、治印為生。
其時，求畫者不多，自是年開始"衰年變法"。
九月，聞家鄉又有戰事，返湘。

一九二〇年	五十八歲　庚申　民國九年

二月，攜三子良琨、長孫秉靈來京。
是年結識梅蘭芳、林琴南、賀履之、朱悟園等。
十一月，還鄉省親。

一九二一年	五十九歲　辛酉　民國十年

春，回北京，應夏午詒之邀，到保定過端陽（端午）節，遊蓮花池。
十月，還鄉省親，不久又回北京。

一九二二年	六十歲　壬戌　民國十一年

是年春，陳師曾攜中國畫家作品東渡日本，參加"中日聯合繪畫展覽會"。
齊白石作品引起畫界轟動，賣價豐厚，並有作品入選巴黎藝術展覽會。

一九二三年	六十一歲　癸亥　民國十二年

陳師曾在南京去世，數次題詩哀悼好友。始作《三百石印齋記事》。

一九二五年	六十三歲　乙丑　民國十四年

二月，大病一場，月餘方癒。
梅蘭芳、徐悲鴻為齊白石印畫集，推崇他"由匠而變，妙造自然"。
此年梅蘭芳正式向齊白石學習畫草蟲。

一九二六年	六十四歲　丙寅　民國十五年

一年之內父母兩喪，傷心之極，兩度停止作畫、刻印。
遷居西城跨車胡同十五號。

一九二七年	六十五歲　丁卯　民國十六年

應林風眠校長之邀，任教於北京藝術專科學校。

一九二八年	六十六歲　戊辰　民國十七年

北京藝術專科學校更名北平大學藝術學院，徐悲鴻任院長，齊白石為教授。
九月，《借山吟館詩草》出版。十月，《白石印草》出版。

一九二九年	六十七歲　己巳　民國十八年

四月，作品《山水》參加教育部在上海舉辦的第一屆全國美術展覽會。

一九三一年	六十九歲　辛未　民國二十年

詩友樊樊山逝世。齊白石兼任京華美專教職。

一九三二年	七十歲　壬申　民國二十一年

七月，樊樊山、吳昌碩題簽，徐悲鴻作序的《齊白石畫冊》由上海中華書局
印行。
十月，部分作品參加"新華藝專教授近作展覽"。

一九三三年	七十一歲　癸酉　民國二十二年
	正月，《白石詩草》八卷印行。
	六月，拓存居京後的第二本印譜凡八十冊，仍冠以王闓運原序，並有自序。
	八月，拓存居京後的第三本印譜計十冊。
	是年，有畫作二十幅被收入魯迅和鄭振鐸編印的《北平箋譜》。
一九三四年	七十二歲　甲戌　民國二十三年
	初春，還湘祭掃先人，回北平後刻 "悔烏堂" 印。
一九三六年	七十四歲　丙子　民國二十五年
	應友人之邀遊四川，五月，遊重慶、成都。九月初，回北平。
一九三七年	七十五歲（自署七十七歲）　丁丑　民國二十六年
	是年起自稱七十七歲。
	七月，北平陷落，辭去教職，閉門家居。
一九三八年	七十六歲（自署七十八歲）　戊寅　民國二十七年
	六月，寶珠生第四個孩子，取名良末。是白石第七個兒子，取號 "耋根"，
	以表 "年八十，尚留此根苗" 之意。
	《三百石印齋紀事》因第六子良年病逝，無意續寫，就此停筆。
一九三九年	七十七歲（自署七十九歲）　己卯　民國二十八年
	貼出告白 "白石老人心病發作，停止見客"。
一九四〇年	七十八歲（自署八十歲）　庚辰　民國二十九年
	妻陳春君去世。撰《祭陳夫人》文。
	《白石自狀略》撰成。
	加貼一張告白 "畫不賣與官家，竊恐不祥"。
一九四三年	八十一歲（自署八十三歲）　癸未　民國三十二年
	年初，在大門貼出 "停止賣畫" 字條。
一九四五年	八十三歲（自署八十五歲）　乙酉　民國三十四年
	八月，日軍無條件投降，恢復賣畫、刻印。
一九四六年	八十四歲（自署八十六歲）　丙戌　民國三十五年
	一月，"齊白石畫展" 在重慶舉行。
	十月，到南京、上海兩地參加中華全國美術會舉辦的齊白石作品展。
	徐悲鴻就任國立北平藝專校長，繼續聘白石為教授。
一九四九年	八十七歲（自署八十九歲）　己丑　民國三十八年
	七月，當選為文聯全國委員會委員、中華全國美術工作者協會全國委員會委員。
一九五〇年	八十八歲（自署九十歲）　庚寅　民國三十九年
	四月，北京藝專改為中央美術學院，受聘為名譽教授，徐悲鴻任院長。
	十月，將一九四一年所畫《鷹》和一九三七年所寫的篆書聯 "海為龍世界，雲是鶴家鄉" 贈送毛澤東。

被聘爲中央文史館研究館員。

一九五一年	八十九歲（自署九十一歲） 辛卯 民國四十年
	二月，作品十餘幅參加瀋陽市“抗美援朝畫義賣展覽會”。
一九五二年	九十歲（自署九十二歲） 壬辰 民國四十一年
	爲亞洲及太平洋地域和平大會作《百花與和平鴿》巨幅。
	榮寶齋用木板浮水印法印製出版《齊白石畫集》。
一九五三年	九十一歲（自署九十三歲） 癸巳 民國四十二年
	一月七日，北京文化藝術界二百餘人爲老人祝壽。
	接受周揚代表文化部授予的“人民藝術家”榮譽獎狀。
	九月，作品參加“第一屆全國畫展”。
	十月四日，當選爲中國美協第一任理事會主席。
一九五四年	九十二歲（自署九十四歲） 甲午 民國四十三年
	四月二十八日，中國美協舉辦的“齊白石畫展覽會”在北京故宮承乾宮開幕。
	五月，東北博物館在瀋陽舉辦“齊白石畫展”。
	紀錄片《畫家齊白石》開拍。
一九五五年	九十三歲（自署九十五歲） 乙未 民國四十四年
	六月，與陳半丁、何香凝等創作巨幅《和平頌》獻給世界和平大會。
	十二月十一日，被授予德國藝術科學院通訊院士榮譽獎狀。
一九五六年	九十四歲（自署九十六歲） 丙申 民國四十五年
	四月二十七日，世界和平理事會宣佈將一九五五年度國際和平獎金授予齊白石。
一九五七年	九十五歲（自署九十七歲） 丁酉 民國四十六年
	五月，北京中國畫院成立，任名譽院長。
	九月十六日逝世於北京。
	《牡丹》爲齊白石最後一幅作品。
一九六三年	被選爲世界十大文化名人之一。

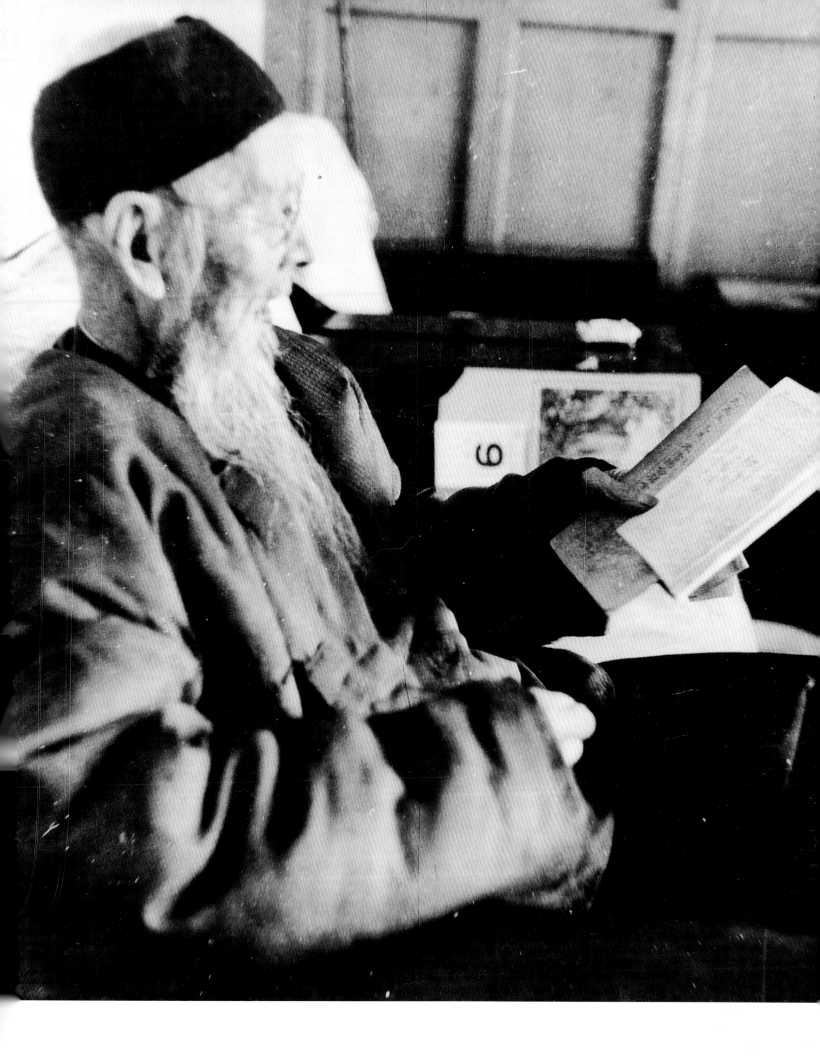

藝術創作紀念展

國家圖書館出版品預行編目資料

齊白石藝術創作紀念展 . 2009 = Art
Exhibition in Memory of Qi Baishi 2009
／ 陳志聲總編輯. --臺中縣清水鎮, 中縣港
區藝術中心 2009.04
88面；23×30公分
ISBN 978-986-01-8219-4 （平裝）
1.書畫 2.印譜 3.作品集
941.5 98006772

Art Exhibition in Memory of Qi BaiShi 2009

指導單位	行政院文化建設委員會、臺中縣政府
主辦單位	臺中縣文化局
	財團法人臺中縣港區文化藝術基金會
	湘潭市齊白石紀念館
協辦單位	國立歷史博物館
	湘潭海峽兩岸經貿文化交流促進會
贊助單位	行政院文化建設委員會、味丹文教基金會
	巨大機械工業股份有限公司
執行單位	臺中縣立港區藝術中心
展覽時間	2009年5月9日～6月21日
展覽地點	臺中縣立港區藝術中心展覽室C

發 行 人	黃仲生
總 編 輯	陳志聲
主 編	許秀蘭
執行編輯	陳柳蒨、張曉玲、劉賢靜
專文論述	羅青哲
篆刻諮詢	高連永
行政支援	李智富、陳蕙美、周炤良、林芬凰、葉淑惠
	蔡佩如、李月妙、劉碧年、徐敘國
美術編輯	吳雪霞
翻 譯	金石翻譯有限公司
圖文提供	湘潭市齊白石紀念館

出版單位	財團法人臺中縣港區文化藝術基金會
	臺中縣立港區藝術中心
地 址	臺中縣清水鎮忠貞路21號
電 話	（04）26274568
傳 真	（04）26274570
網 址	www.tcsac.gov.tw
印 刷	立夏文化事業有限公司

發行日期	2009年4月
印 刷 量	2000本
定 價	新臺幣500元整
統一編號	1009800924
國際書號	978-986-01-8219-4 （平裝）

Supervisor	Council for Cultural Affairs, Taiwan Taichung County Government
Organizer	Taichung County Cultural Affairs Bureau
	Taichung County Seaport Culture and Arts Foundation
	Xiantan City Museum of Qi Baishi
Co-Executor	National Museum of History
	Xiang-Tan Cross-Strait Economic, Trading and Cultural Promotion Association
Sponsor	Council for Cultural Affairs, Taiwan
	Vedan Cultural Foundation
	Giant Manufacturing Co. Ltd
Executor	Taichung County Seaport Art Center
Date	May 9, 2009 ~ June 21, 2009
Venue	Exhibition Room C in Taichung County Seaport Art Center

Publisher	Huang, Chung-Sheng
Editor-in-Chief	Chen, Chih-Sheng
Editor	Hsu, Hsiu-Lan
Executive Editor	Chen, Liu-Chien Chang, Hsiao-Ling Liu, Hsien-Ching
Exposition of the Special Article by	Lo, Ching-Che
Sculpture Consultant	Gao, Lian-Yong
Administration support	Lee, Chi-Fu Chen, Hui-Mei Chou, Chao-Liang
	Lin, Fen-Huang Yeh, Shu-Hui Tsai, Pei-Ju
	Li, Yuem-Miao Liu, Bi-Nien Hsu, Hsu-Kuo
Graphic Designer	Wu, Hsueh-Hsia
Translators	Kingston Translation Service Co., Ltd
Photo and Composition by	Xiantan City Museum of Qi Baishi

Published by	Taichung County Seaport Art Center
	Taichung County Seaport Culture and Arts Foundation
Address	No.21, Jhang-Jhen Road, Cingshuei Township,
	Taichung County, Taiwan 43468, R.O.C
TEL	886-4-26274568
FAX	886-4-26274570
http	//www.tcsac.gov.tw
Printing	Summertime Publishing Co., Ltd

Publiciation Date	April, 2009
Printing quantity	2000 copies
Price	NT500
GPN	1009800924
ISBN	978-986-01-8219-4 (Paperback)

卯足頗色大部保紅，保有些暗色者。